POSTCARD HISTORY SERIES

Providence

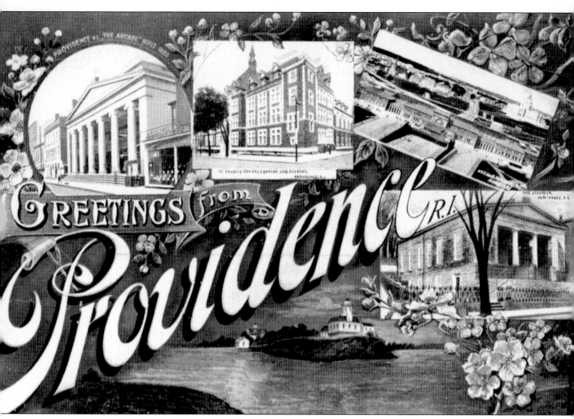

GREETINGS FROM PROVIDENCE. Postcards of this type were very popular in the first couple of decades of the 20th century. Seen here are (clockwise from the left) the Arcade; St. Francis Xavier Convent and Academy; the New York, New Haven and Hartford Railroad Station (also known as the Union Station); and the Providence Athenaeum. One got a lot of bang for one's buck (or penny) with a card like this because it had four views, not just one as with other cards.

On the Front Cover: **LOOKING EAST ON WEYBOSSET STREET.** The structure in the center of the view is one of downtown's comfort stations. This one was built in 1913 and was designed by Martin and Hall, architects. Providence took its comfort stations seriously back then. The Outlet Company is seen on the right. (Courtesy of Louis McGowan.)

On the Back Cover: **LOOKING WEST ACROSS THE PROVIDENCE RIVER.** Seen here are three steamboats, including the *Newport*. The Providence waterfront at this time was split between excursion craft and working boats that brought finished goods and supplies in and out of the port. (Courtesy of Louis McGowan.)

POSTCARD HISTORY SERIES

Providence

Louis McGowan and Daniel Brown

ARCADIA

Published by Arcadia Publishing
Charleston SC, Chicago IL, Portsmouth NH, San Francisco CA

Printed in the United States of America

Library of Congress Catalog Card Number: 2005936498

For all general information contact Arcadia Publishing at:
Telephone 843-853-2070
Fax 843-853-0044
E-mail sales@arcadiapublishing.com
For customer service and orders:
Toll-Free 1-888-313-2665

Visit us on the Internet at http://www.arcadiapublishing.com

I would like to dedicate this book to my father, Louis C. McGowan, who passed on to me his love of collecting in general and his love of collecting postcards in particular. (LHM)

I would like to dedicate this book to my grandfather, Harry Burke, who was born and lived in Providence and spent his life working in the city at the Outlet Company, Kennedy's Clothing Store, and at Roger Williams Park. (DB)

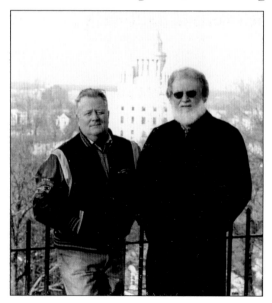

AUTHORS. Daniel Brown (left) and Louis McGowan (right) pose in Prospect Terrace on Congdon Street in the East Side. Given to the city in 1867, the small park is the site of a memorial statue of Roger Williams. Great views of the city can be had here.

CONTENTS

ACKNOWLEDGMENTS

We would like to thank the Rhode Island Historical and Preservation Commission for its wonderful reports on Providence from which we gathered much information for captions. We would like to thank the great folks at the Rhode Island Postcard Club. Many of the postcards used in this book were purchased at their monthly meetings. Personal thanks go to my late father, Louis C. McGowan. A number of his postcards were used in this book.

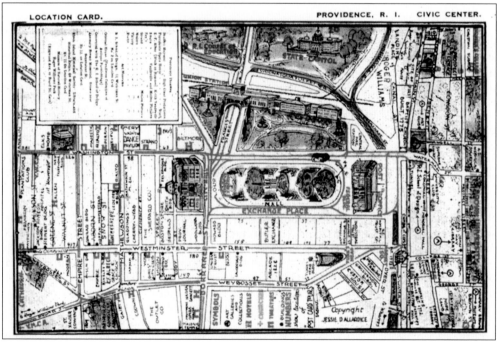

PROVIDENCE CIVIC CENTER. This map postcard shows many of the cultural, hotel, business, historical, and government buildings of the downtown. The postcard is from around the 1920s.

INTRODUCTION

This book will focus on the first half of the 20th century. Most of the postcard images date to the first three decades of that period. Those early years were the golden era for postcards. Literally billions of cards were sent through the mail during that time.

Roger Williams founded Providence in 1636 after he was driven from the Massachusetts Bay Colony because of his religious beliefs. He set up the new settlement around a fresh spring on what came to be known as Towne Street (today North Main Street). A formal deed for the land was secured from the Narragansett tribe, and house lots for new settlers were set up extending from Towne Street up and over College Hill. Farming, fishing, and fur trading were the chief economic pursuits.

Providence grew slowly until after the Revolutionary War when it surpassed Newport as the largest city in the colony. Starting with a new wharf built in 1680, Rhode Island entered the maritime trade, which soon changed the city into a major commercial center. The slave trade, privateering, and regular commercial trade brought great wealth to Providence, which in turn meant great homes and other buildings were built. The city's social and cultural life also blossomed. The wealthy took part in establishing schools, churches, and later museums.

Providence played a major role in the Revolution starting with the 1772 burning of the *Gaspee*, a British revenue vessel. The raid was planned in Providence and led by Providence patriots. Local boy Esek Hopkins was appointed the first commander in chief of the United States Navy.

By the early to mid-19th century, industrialism had replaced commercialism as the city's economic foundation. Providence also became a major rail center, providing necessary track for industry. The textile, jewelry, silver, and machine tool companies led the way in the economic boom, bringing in large numbers of foreign-born immigrants to supply labor for the new industries. By the late 19th century, Providence boasted of its "Five Industrial Wonders of the World." It was the home of the largest tool factory (Brown and Sharpe), file factory (Nicholson File), screw factory (American Screw), steam engine factory (Corliss), and silverware factory (Gorham). At one time, Providence was sixth in industrial production in the country and in the top 20 in population. Over 250,000 people lived in Providence in the 1920s. Individuals from many ethnic groups came to Providence for a better life and contributed to the city's rich fabric.

After the first few decades of the 20th century, things started to change. The textile industry was dying out and the "big five" were struggling. The jewelry industry moved to the forefront. Led by Gorham and 300 smaller plants, Providence became the country's jewelry capital by the 1920s, especially in costume jewelry. A slump after World War I and then the Great Depression greatly hurt the city's economy, and the city suffered. Many middle-class residents moved to

the suburbs in the 1950s and 1960s. In their place came new groups of immigrants, first mainly from South-East Asia and later from various Latin American and African nations.

Little building activity went on in downtown Providence from the Great Depression through the 1950s. This was a good thing for Providence's old buildings of course, because what is left is a wonderful collection of 19th and early 20th century commercial and government buildings. Coupled with one of the best collections of late 18th and early 19th century houses in the country on the East Side, Providence has a very rich array of important buildings that have been used in a number of creative ways.

The cultural and social life in Providence has remained strong. There is a nationally famous repertory company (Trinity Square Repertory Company), many first-class restaurants, a number of first-rate colleges, the renowned Rhode Island School of Design Art Museum, a superb zoo at Roger Williams Park, and a very active community of artists, musicians, and craftspeople.

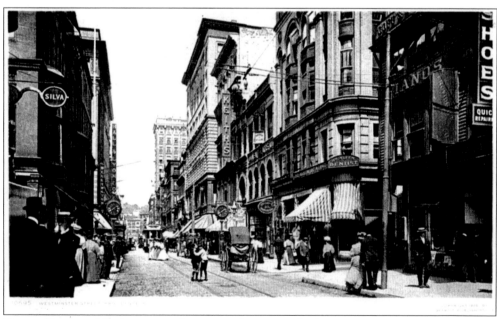

EARLY VIEW OF WESTMINSTER STREET. This view is looking east up Westminster Street in this wonderful *c.* 1905 postcard. No automobiles are to be found, only horse-drawn vehicles and trolleys. Some of the signs in the view include "British Club," "Keith's Theatre," and "Goff's Pianos." Note the two advertising clocks directly across the street from each other. The street takes its name from the town of Westminster in London.

One

DOWNTOWN

THE HEART OF THE CITY

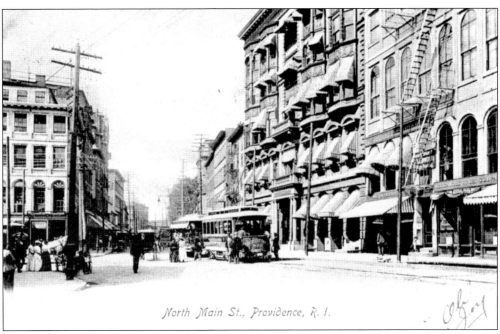

North Main St., Providence, R. I.

NORTH MAIN STREET FROM MARKET SQUARE. The trolley in front is headed to Crescent Park, a popular amusement park in East Providence. Main Street, north and south, was originally the old Towne Street, the most important street of Roger Williams's original settlement. The buildings in the background constituted a fashionable 19th-century shopping area known as Cheapside, named after a section of London, England.

INFANTRY HALL ON SOUTH MAIN STREET. The city's major civic auditorium 100 years ago, Infantry Hall contained an assembly room on the second floor that was 75 feet by 40 feet and was used for a variety of purposes, including musical performances, prize fights, banquets, and political rallies. The building was built between 1879 and 1880 by Providence's First Light Infantry Regiment. Three presidents spoke here: McKinley, Theodore Roosevelt, and Taft. A fire in 1942 destroyed the building.

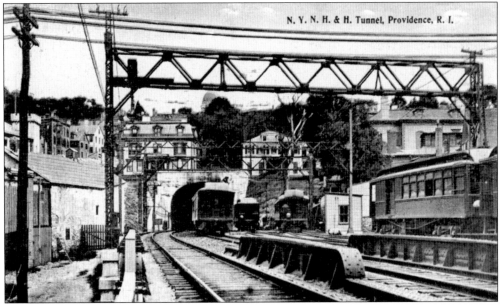

THE WEST ENTRANCE TO THE COLLEGE HILL TUNNEL. The tunnel was used by trains going to points east and southeast of Providence. Construction of the tunnel, cut under the East Side of Providence, was quite an engineering feat for the time. This entrance is just north of Angell Street and just east of North Main Street. The trains exited the tunnel on the east side of Gano Street. The cars that are seen here were owned by the Providence, Warren and Bristol Railroad, which was an early electrified main line railroad.

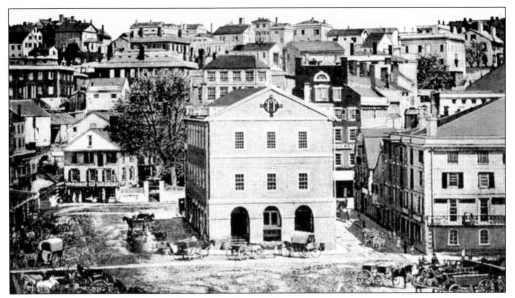

A View Looking East at College Hill. This postcard view made from a very early photograph (1844) was made in Germany before World War I and was hand-colored before printing. The Market House, the central building, was erected in 1773 and was the first known Providence building erected for commercial use. Designed by Joseph Brown, brother of the famous John Brown, it originally had two stories with its first floor open for vendors' stalls. From 1773 until the 1920s, the surrounding area made up the city's market place.

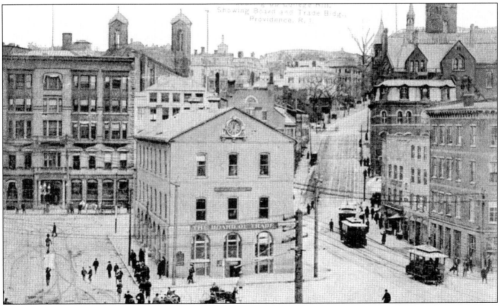

College Hill Looking East. Many changes have been made in this view of the same area about 60 years or so later. In 1797, a third story was added to the Market House building to house the first Masonic hall in the state. City hall was located here from 1865 to 1868, and the Providence Board of Trade was here from the 1870s until the 1920s. On the right can be seen trolleys that used the cable tramway (utilizing a cable to pull the cars) to navigate up the steep College Hill. The Market House is now used by the Rhode Island School of Design.

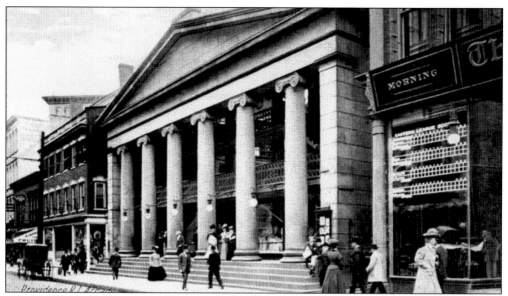

THE PROVIDENCE ARCADE, 1828. One of the most significant buildings in Providence, this three-story, stone Greek Revival structure was built by Cyrus Butler as a commercial property. It features three levels of shops in a mostly original interior. Its Westminster and Weybosset Street facades are different, as each was designed by one of the architects, Russell Warren and James Bucklin. Note the building on the right where baseball scores were updated (no radio broadcasts then) so folks could follow their favorite teams.

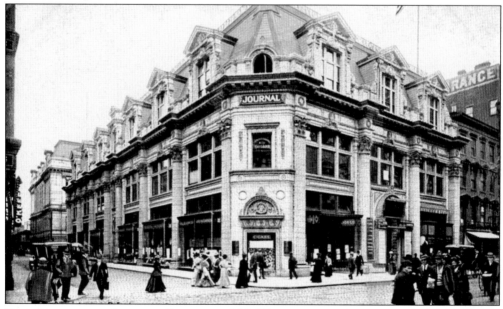

THE PROVIDENCE JOURNAL BUILDING, 203 WESTMINSTER STREET. Built in 1906 in the French Renaissance Style, it was the home of the *Providence Journal* newspaper (founded in 1829) from 1906 until the company moved to Fountain Street in 1934. The building has been used by various shops and businesses since the 1930s. In the 1950s, when the J. J. Newberry variety store was located there, the structure was covered with metal panels from the cornice down. It was restored to its original look in the 1980s.

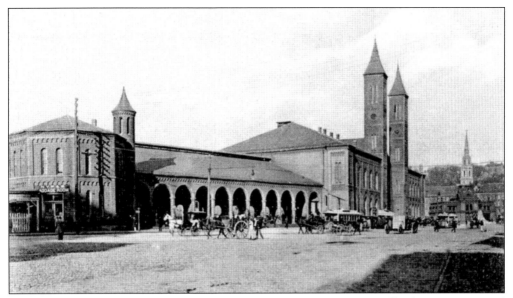

THE FIRST UNION STATION. Designed by local architect Thomas Tefft, the station opened in 1848. Located in the middle of the present Kennedy Plaza, it was called the Union Station because it served as the terminal for the three main train lines coming in to Providence. This attractive complex of buildings formed the first major American railroad station. It was destroyed by fire in 1896. The fire was seen as suspect because plans had already been approved to replace it with a larger and more convenient station.

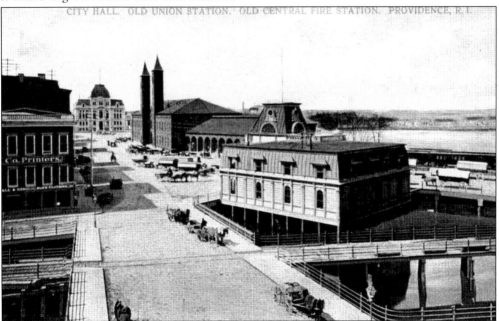

EXCHANGE PLACE, AROUND 1890. This early view shows the remarkable Union Railroad Station (1848) with the cove in the background. The building in front was the Central Fire Station (1873), which additionally housed various city offices on the second floor. In 1903, the fire department moved to a new building just to the north of the 1873 station, which was torn down at that time.

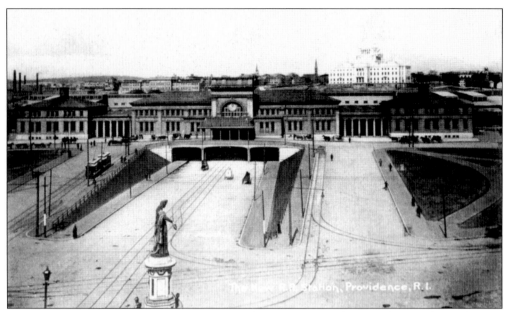

THE SECOND UNION RAILROAD STATION. This postcard, made around 1904, shows the new station (1898). In the background, the grounds of the new statehouse are not yet completed. The train station replaced the first Union Station (1848), which stood 500 feet south. The location of the second station made for an easy connection with trolley and bus lines. The station is no longer used by the railroad, but has been preserved and is now used by various organizations.

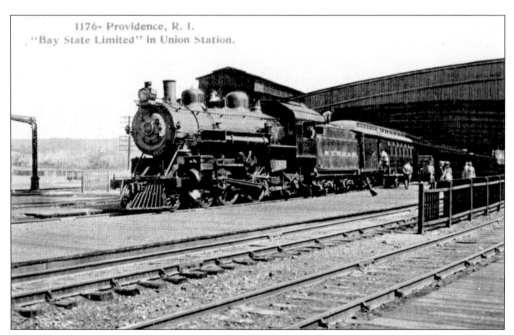

A NEW YORK, NEW HAVEN AND HARTFORD RAILROAD TRAIN. Waiting for the trip south, the train is loaded in the yard of the old Union Station (1898). The passenger cars are covered by a shed-roofed structure erected to keep passengers out of the elements. The station, still standing, has been replaced by a newer Providence Station, a few hundred yards north.

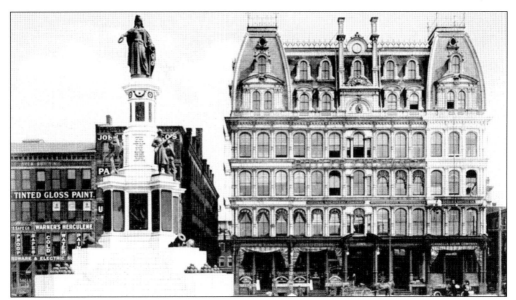

THE BUTLER EXCHANGE, AROUND 1910. The building was erected in 1873 in the Second Empire Style. It was the largest private structure built in the city in the post-Civil War boom. On the first level was a shopping arcade, while the other five floors provided office space. It was developed by Cyrus Butler, who also built the Arcade. The Exchange was demolished in 1925 to make way for the Industrial National Bank Building. The 1871 Soldiers and Sailors Monument is seen on the left at its second location.

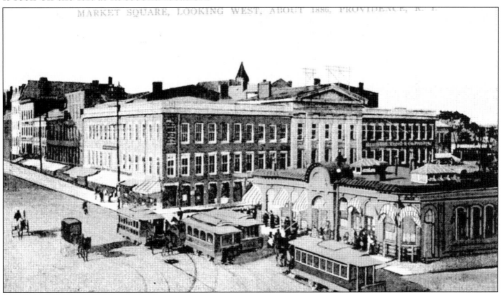

THE UNION RAILROAD DEPOT. In the right foreground stands the depot that was built in 1867 in Market Square. The Union Railroad Company, the first street railway in the city, began operation in 1865. In this view from about 1886, the railcars are shown still being drawn by horses. The building was demolished in 1897. In back of the depot is the Washington Building, dating from 1843 and designed by James Bucklin for the Providence Washington Insurance Company. That structure was razed for the Hospital Trust Building, which was erected on the site in 1919.

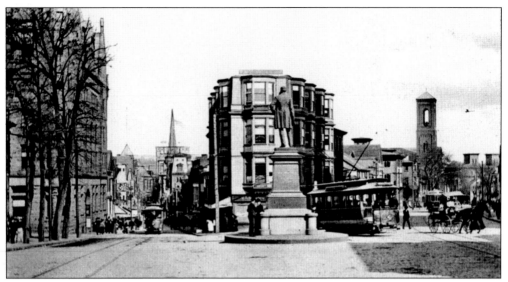

CATHEDRAL SQUARE, AROUND 1905. Most of the buildings in this view have been razed. The YMCA (left) is long gone, as is the large office building in the center of the scene. Most of the houses on Westminster Street (left) and Weybosset Street (right) have been demolished. The Cathedral of Sts. Peter and Paul is out of view on the right. Many of the buildings here were leveled in the 1960s to create a plaza in front of the cathedral. The 1889 monument of Mayor Thomas A. Doyle, in the center, was moved to Chestnut Street at that time.

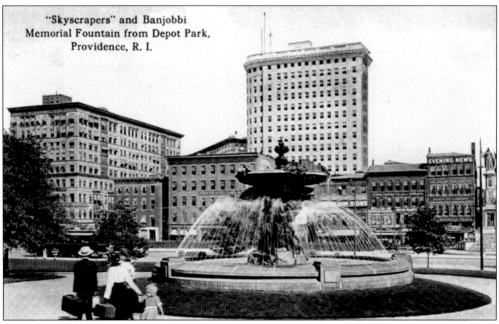

"Skyscrapers" and Banjobbi
Memorial Fountain from Depot Park,
Providence, R. I.

A VIEW LOOKING SOUTH ACROSS EXCHANGE PLACE, NOW KENNEDY PLAZA. The Turks Head Building, the tallest building in Providence at the time, looms over the city. The building on the extreme left is the Industrial Trust Building. The Bajnotti Fountain (center), sculpted by Enid Yandell, was built in 1899 and was given to the city in memory of Carrie Brown Bajnotti by her husband, Paul. Carrie was a daughter of Nicholas Brown III.

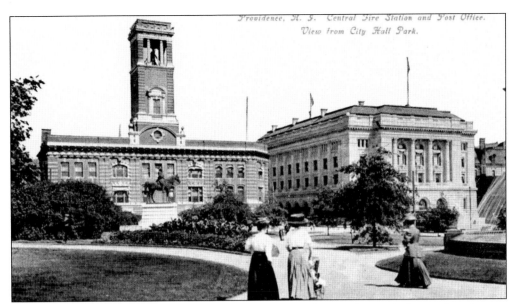

THE CENTRAL FIRE STATION (LEFT) AND THE POST OFFICE (RIGHT). Located on the east side of Exchange Place, the fire station dated to 1903 and was replaced in 1938 by the Federal Building Annex, now called the John O. Pastore Building. The post office was built in 1908 in the Beaux-Arts Neoclassical Style. It was built to relieve the pressure for space at the 1857 Federal Building on lower Weybosset Street. The post office is now called the Federal Building. The 1887 Gen. Ambrose E. Burnside statue is situated in front of the fire station.

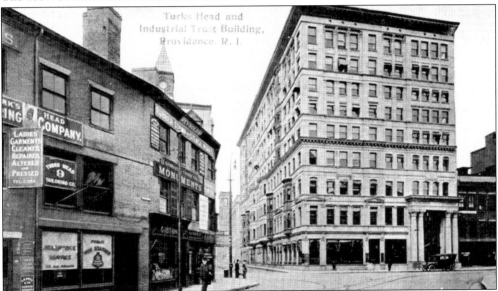

THE TURKS HEAD BUILDING (LEFT) AND THE INDUSTRIAL TRUST BUILDING (RIGHT). The Turks Head Building was torn down in the early 20th century and was replaced by a building with the same name. The present 17-story Turks Head Building was completed in 1913 on the site of the 1850 Whitman Block/Turks Head Building pictured here. The Industrial Trust Company was founded in 1887, and the building on the right was its first home. The bank moved to a new skyscraper in 1928, and the building shown here was demolished in the 1970s to make way for the Hospital Trust Tower.

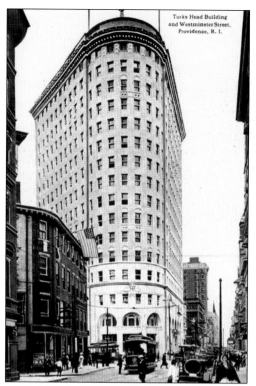

THE TURKS HEAD BUILDING. Located at the intersection of Westminster and Weybosset Streets, this building was the tallest in New England when it was completed in 1913. It was built by the Brown Land Company as an investment property for the Brown family. It has housed stock brokerages, insurance firms, and a bank since its opening. The Turks Head Building is important both for its architecture and its role in the commercial history of Providence.

THE GOLDEN BALL INN, BENEFIT AND SOUTH COURT STREETS. The best known and the most important of the early inns in Providence, the Golden Ball Inn often provided lodging to Providence visitors who had business at the Old State House at 150 Benefit Street. Distinguished guests included the Marquis de Lafayette, Mrs. John Adams, and Thomas Jefferson. Only a rear ell on South Court Street remains of the original building.

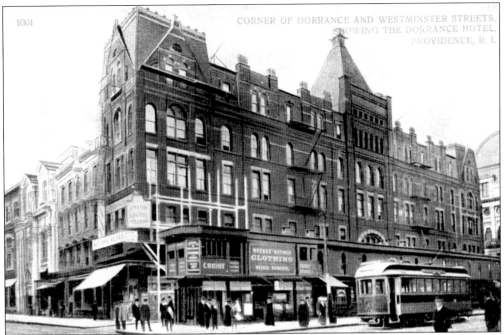

THE DORRANCE HOTEL, WESTMINSTER STREET. The hotel was completed in 1880 from designs by Stone, Carpenter and Wilson, Rhode Island's leading architects. It was located at Dorrance and Westminster Streets. The owners of the hotel were J. T. and A. M. Beckwith. In 1882, the rates for the 120 rooms were $2.50 to $4.00 per day. The building, made of brick with terra cotta trim, is no longer standing and was replaced by the present Woolworth Building.

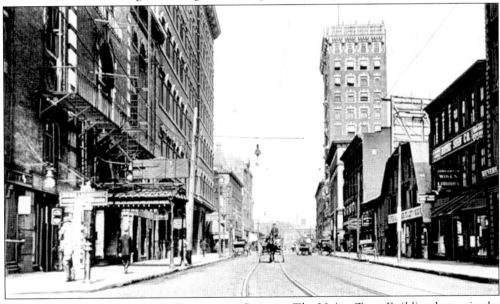

A VIEW LOOKING NORTH UP DORRANCE STREET. The Union Trust Building looms in the right-center of this scene. Also on the right is a wood-frame building where carriages were leased—by the hour if necessary. The building on the extreme left housed the Providence Opera House, which opened in 1871 and remained the city's leading true theater into the 1920s. The building no longer stands.

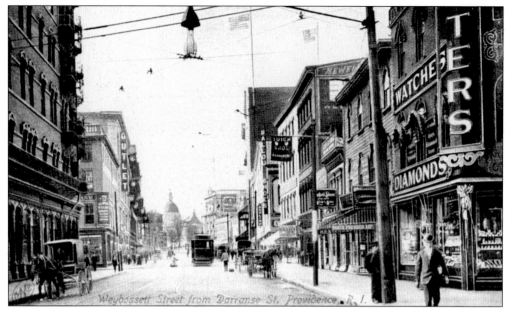

A View Looking West Up Weybosset Street. In this great view taken from the corner of Dorrance Street, the Narragansett Hotel is on the immediate left and the Outlet Company is two buildings west. In the distance, the dome of the Beneficent Congregational Church can be seen. On the right side of the street are signs advertising a bowling alley, two shoe stores, and Foster's Jewelry Store.

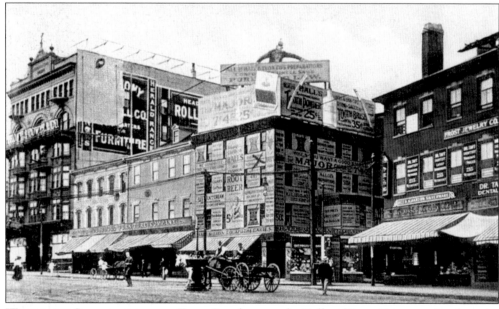

Weybosset Street from the East. Seen here are the Hall and Lyon Company Apothecaries building at the corner of Mathewson Street. The building was covered with advertisements. Sometimes messages on the back of cards give details that might not be known otherwise. The writer notes that Hall and Lyon ran four large stores in Providence. He also writes that the Anthony and Cowell's Furniture Store building (far left) burned to the ground four years earlier. Since the card was dated 1904, the building was destroyed around 1900.

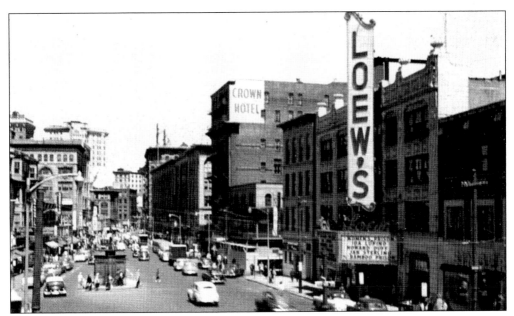

A view Looking East Down Weybosset Street. On the right is the Loew's theater. It was built in 1928 on the site of the Gaiety Theatre and operated as Loew's State and Loew's until 1971. For a short time in the 1970s, it ran as the Palace Theatre and then as the Ocean State Theatre. In 1978, it became the Providence Performing Arts Center, which was and still is a major regional cultural center.

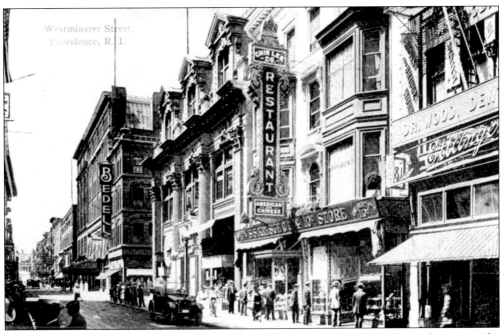

Westminster Street from the East. The S. S. Kresge 5 and 10¢ Store can be seen in the second building from the right. Kresge had a long-time presence in the downtown area. This building was replaced in the 1930s by the still-standing Kresge Building. To the left is the old Providence Journal Building and one building left of that is the elaborately decorated Gaspee Building.

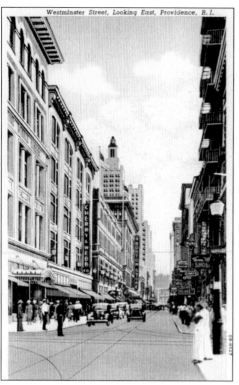

A View Looking East Down Westminster Street. Stores like Shepards, Cherry and Webb, the Boston Store, and the Outlet Company (where author Daniel Brown's grandfather sold men's suits for 30 years) pointed to the downtown being the place to shop.

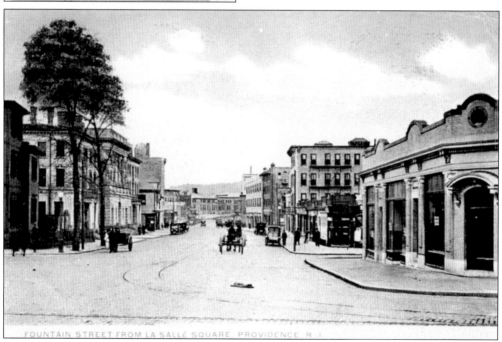

Fountain Street Looking East. Seen here is a *c.* 1910 commercial building on the right. The second building on the left is the Central Police Station, long demolished. In the far distance, in the center of the road, is the Union Railroad Station. Every building on the left-hand side of the street has been torn down. A few of the buildings on the right still stand.

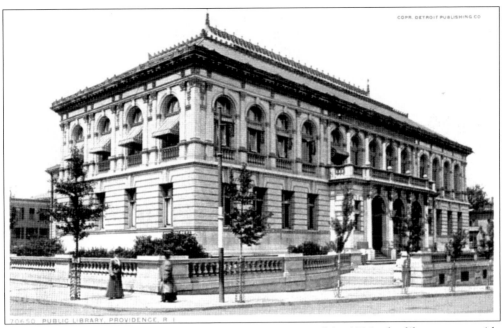

THE PUBLIC LIBRARY, WASHINGTON STREET. Erected in 1900, the library won wide acclaim for its handsome design. A 1954 addition, fronting on Empire Street, gave the library much-needed space to expand. The Providence Public Library was established in 1875, occupying three other buildings before moving here in 1900. Funds to build the structure came largely through a gift from John Nicholas Brown.

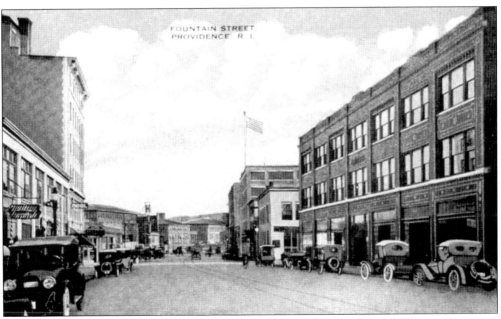

FOUNTAIN STREET. The 1898 railroad station is seen at the far end of the street. The street name comes from the spring located near the intersection of Dean and Fountain Streets. The spring supplied water to the eastern part of downtown through hollow logs laid in 1772. The postcard dates from the 1920s.

23

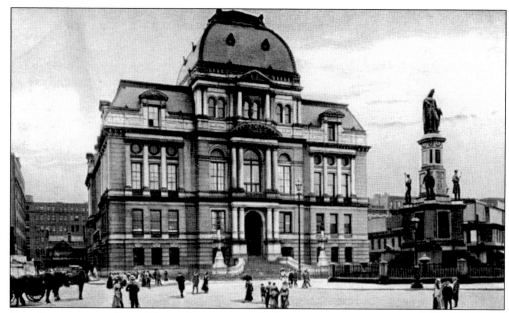

THE PROVIDENCE CITY HALL. A monumental, five-story, granite, Second Empire building, the city hall is richly decorated inside and out. The building is based directly on Boston's old city hall. The building bears testimony to 19th-century civic pride, but it was slated for demolition as part of the city's master plan in the late 1970s. The Soldiers and Sailors Monument stands in its original position.

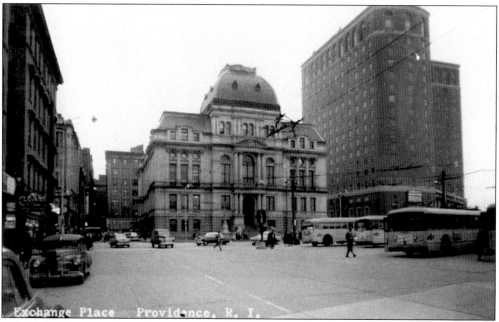

THE CITY HALL, 1950s. The Biltmore Hotel has been added to the scene and the Soldiers and Sailors Monument is missing (moved further east). Built between 1874 and 1878, city hall sits on a full city block at the head of Kennedy Plaza. The interior is dominated by a magnificent five-story stairwell. In 1975, the building underwent a major renovation, bringing it back to its original elegant state.

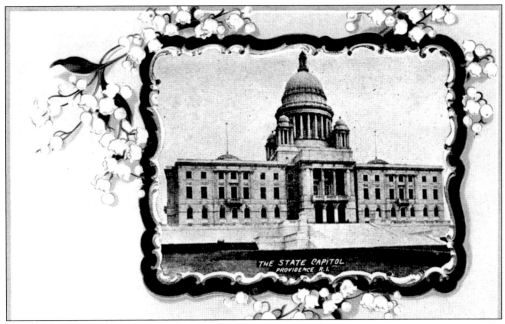

THE RHODE ISLAND STATE HOUSE. In 1891, the state chose a 16-acre site on a rise at the foot of Smith Hill on which to build the statehouse. Completed in 1904, it is one of the most magnificent capitol buildings in the country. The old statehouse at 150 Benefit Street is a short distance away and is visible from the new statehouse. Designed by McKim, Mead and White, it is constructed of white marble and is capped by an unsupported dome.

THE ELKS BUILDING. The national Elks organization was founded in 1868, and the Providence Elks Lodge was one of the oldest lodges in the country. This postcard shows the new building on Washington Street, not far from the Providence Public Library. The building no longer stands. The lodge moved first to Elmwood, then to Johnston, and finally merged with a Pawtucket lodge.

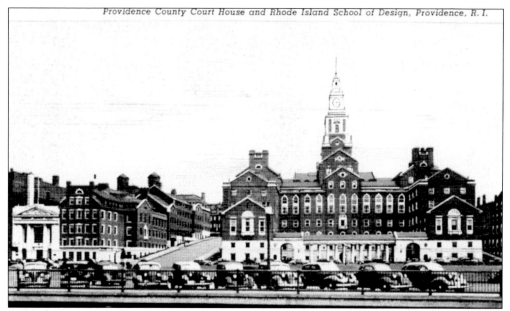

THE PROVIDENCE COUNTY COURTHOUSE. Erected between 1924 and 1933, the courthouse is a nine-story Georgian Revival structure built into the western slope of College Hill and stretching from Benefit Street to South Main Street. The building replaced the 1877 Superior Courthouse. The buildings on the left are owned by the Rhode Island School of Design.

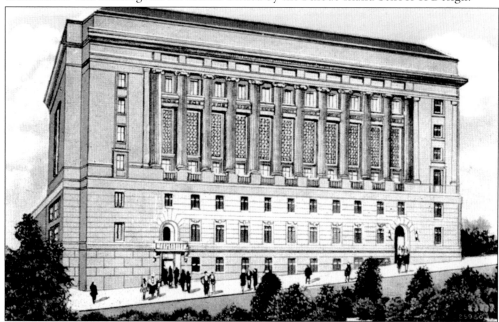

THE MASONIC TEMPLE, FRANCIS STREET. Situated directly across from the statehouse, this 1920 view shows people milling around the entrances. This scene is totally fabricated because the building was never completed. Construction started on the project in 1926, but money ran out in 1928 with only the walls and roof completed. It has been sitting incomplete ever since. The state purchased the property in 1945 and completed the auditorium wing in 1951. In 2004, work was finally started on a luxury hotel that will use the grand old shell.

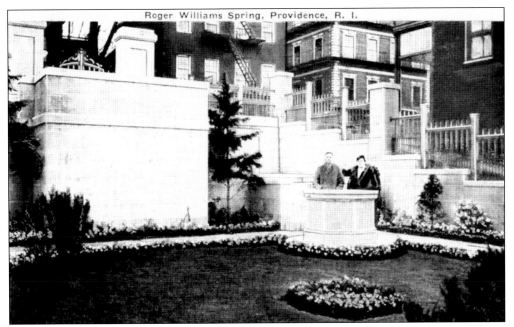

Roger Williams Spring, Providence, R. I.

THE ROGER WILLIAMS SPRING, NORTH MAIN STREET. Today part of the Roger Williams National Memorial Park, the spring is what attracted Williams and his followers to the site in 1636. By 1930, both sides of North Main Street were lined with buildings and the spring was concealed in a cellar. In 1931, the plot of land containing the spring site was given to the city by Judge J. Jerome Hahn in memory of his father. The National Memorial Park came into being in 1981, and today four acres of park surround the spring on three sides.

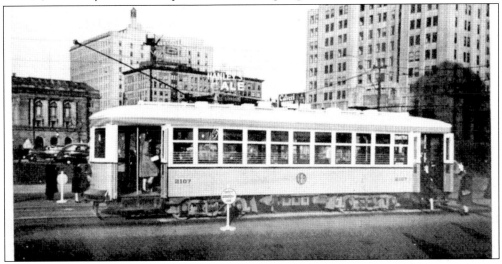

UNITED ELECTRIC RAILWAY CAR (UER). The UER was the successor to the Rhode Island Company, the trolley giant in Rhode Island. UER purchased all of the Rhode Island Company's trolley lines and began operation under its own name in 1921. By the time of this postcard view, which shows a trolley in Exchange Place in 1940, UER had replaced most trolleys with gasoline-powered buses. The UER became the United Transit Company in 1952, and it in turn became the Rhode Island Public Transit Authority (RIPTA) in 1966. RIPTA still operates most of the buses in the state.

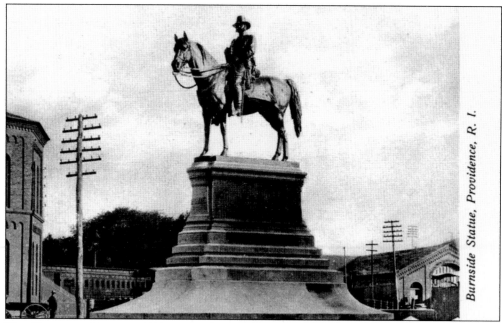

Burnside Statue, Providence, R. I.

THE BURNSIDE STATUE, 1887. Erected in 1887 in Exchange Place Mall at the eastern end of the first Union Station (1848), the statue was moved in 1906 to the park in front of the old Central Fire Station (1875). Gen. Ambrose Burnside was active during the Civil War, was a rifle manufacturer, a governor of Rhode Island for three years, and United States senator for six years.

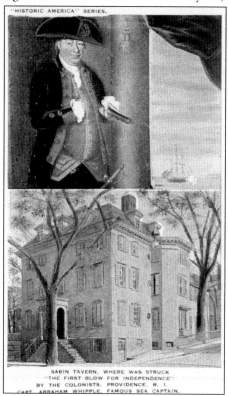

SABIN TAVERN, WHERE WAS STRUCK
"THE FIRST BLOW FOR INDEPENDENCE"
BY THE COLONISTS, PROVIDENCE, R. I.
CAPT. ABRAHAM WHIPPLE, FAMOUS SEA CAPTAIN.

THE SABIN TAVERN. On the night of June 9, 1772, a group of Rhode Island patriots made plans to burn the grounded British schooner, HMS *Gaspee*. It was one of the first blows for liberty by the Colonists against the British. The tavern no longer stands, but a monument marking the site sits on South Main Street. Capt. Abraham Whipple, pictured here, commanded one of the seven longboats used during the raid.

Two

WHERE PEOPLE LIVE

THE NEIGHBORHOODS

BROADWAY. One of Providence's more fashionable addresses in the 1850s, Broadway was close to downtown but had enough open land on which to build large houses. Originally laid out in the 1830s, it was widened to 80 feet in 1854. Many elaborate homes were built by the city's wealthy merchants and manufacturers. In this view is a Broadway-Phillipsdale trolley. The trolleys enabled residents to live farther from their jobs. The unfortunate trolley operator is out in the elements in his open-front car.

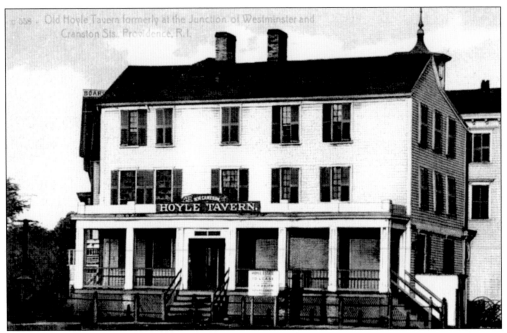

THE HOYLE TAVERN. Established in 1739 by Obadiah Brown, the tavern was located at the junction of Cranston and Westminster Streets. By 1783, a small hamlet grew up around the tavern. The Hoyle was demolished in 1890. Today a Citizen's Bank, erected in 1921, is located on the site. The area is still known as Hoyle Square.

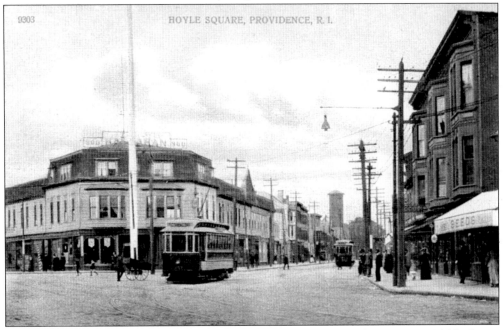

HOYLE SQUARE. After the Hoyle Tavern was torn down in 1890, this commercial block was built on the site. Cranston Street ran along the left side of the building, and Westminster Street ran off toward Olneyville on the right. The block was demolished for the construction of the Citizen's Bank Building in 1921.

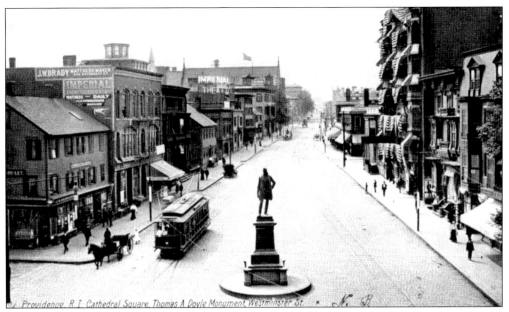

CATHEDRAL SQUARE. This view from Cathedral Square looks west down Westminster Street. The monument of longtime Mayor Thomas A. Doyle stands in the foreground. It was moved to the corner of Chestnut and Broad Streets in 1969. A variety of businesses occupy the buildings shown, including rooming houses, a theater, an undertaker, and a mattress maker. Most of the buildings shown here have been torn down.

TRINITY SQUARE. Situated at Broad Street and Elmwood Avenue, the Trinity Square officially came by its title in 1875, when it was named for the Trinity United Methodist Church, which is on the northwest side of the square. In the 1850s and after, the Elmwood area (which includes the square) was a fashionable middle-class neighborhood. The trolleys made it easy for residents to commute to work in the downtown area. Note the horse-drawn tanker vehicle on the right, its purpose unknown.

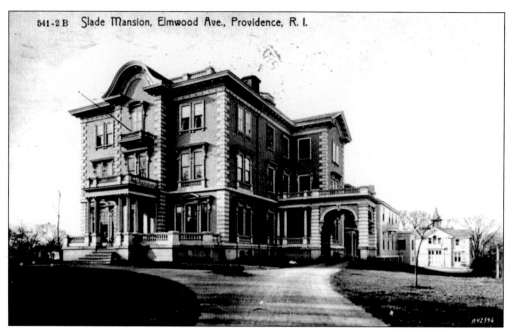

541-2 B Slade Mansion, Elmwood Ave., Providence, R. I.

THE GEORGE H. SLADE MANSION. Built around 1877 on Elmwood Avenue at Reservoir Avenue in the Elmwood section, this was one of the largest homes in the area. Erected for George H. Slade, a retired wholesale grocer, this opulent mansion burned in 1919.

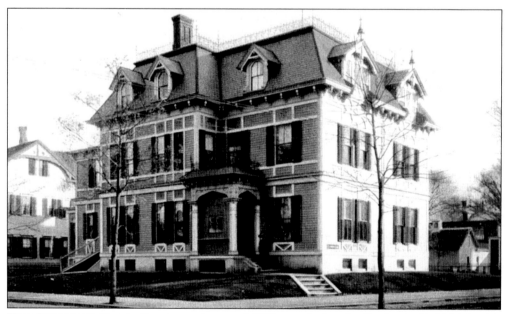

THE ELMWOOD CLUB. Constructed around 1875 as a duplex for Benjamin F. Aldrich, this ornate, mansard-roofed, stick-style building became the home of the Elmwood Club in 1890. The club was for men only, and many of Elmwood's prominent businessmen belonged. Bowling alleys, billiard and card rooms, parlors, a library, and a dancing parlor were all found at the club. The Elmwood Club closed in 1910, and the structure was re-named the Princess and operated as an apartment house after that.

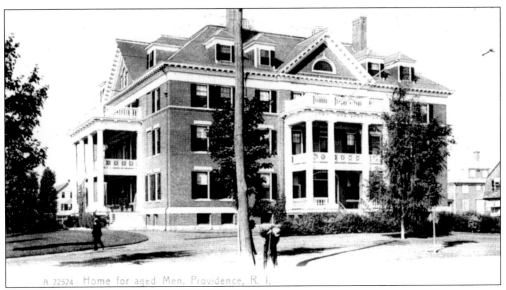

THE HOME FOR AGED MEN. The home was sited at 807 Broad Street in south Providence. A home for aged men had existed in the city since 1874 at other locations. When Henry J. Steere died, he left $150,000 to build a new structure for elderly men. This Broad Street building was completed in 1895, and within a few years the facility was expanded to accommodate aged couples.

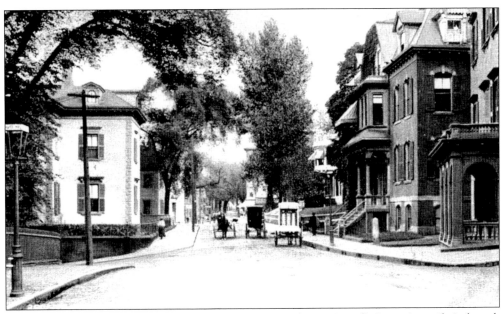

BENEFIT STREET. The most famous old street in Providence, Benefit Street is a mile in length and extends from Wickenden Street to North Main Street. This view looks north along Benefit Street from the intersection with Angell Street. It was built between 1756 and 1758. The old statehouse was constructed at 150 Benefit Street, and new houses were erected in the 1760s. It remained a fashionable address until the late 19th century. After a period of decline in the middle of the 20th century, it is once again populated by homeowners.

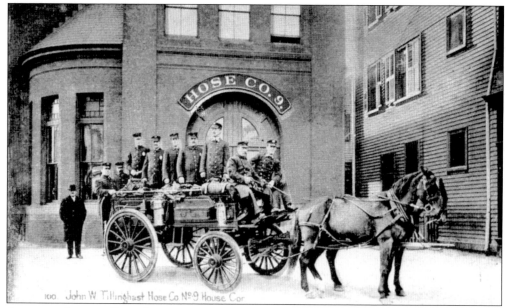

ATWELLS AVENUE FIRE STATION, HOSE COMPANY NO. 9. This card is one of a wonderful series of postcards showing the fire stations of Providence. Hose Company No. 9 was located at Atwells Avenue and America Street in the Federal Hill section. Their hose-wagon was made in 1896 and was drawn by two horses. The company consisted of one captain, one lieutenant, six horsemen, and one driver.

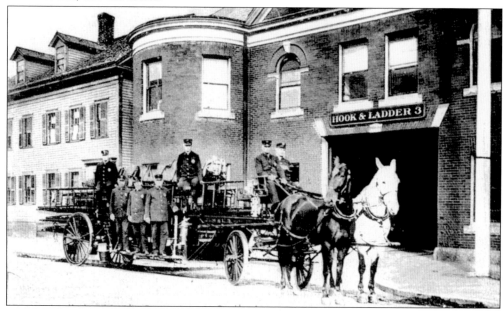

DOUGLAS AVENUE FIRE STATION. The station is seen on another card from the fine series of firehouse postcards published by the R. Wilkinson Company. The Union Hook and Ladder Company No. 3 House still stands on Douglas Avenue. It is now occupied by a restaurant. The building was built in 1902 and was used as a fire station until 1949. The truck pictured here is a Seagrave trussed truck that was made in 1901. The fire company consisted of a captain, a lieutenant, five ladder men, and a driver.

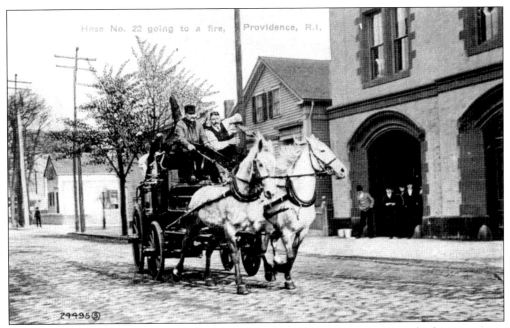

RESPONDING TO A FIRE. Going off to a fire in a horse-drawn wagon may look romantic to us, but firefighting was a difficult and dangerous job then as it is now. The Providence Fire Department became a professional unit in 1854 and has kept up with equipment changes and techniques since then.

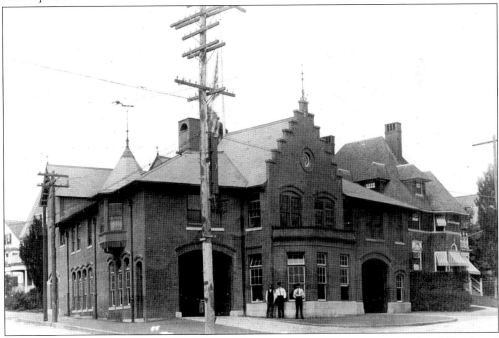

ENGINE COMPANY NO. 5. This fire station, housing Engine Company No. 5 and Hook and Ladder No. 7, dates from 1892, when it was opened at the intersection of Hope and Olney Streets on the East Side. It was closed and sold by the city in 1951. Since then it has been used for a variety of commercial uses, including a long-standing Mexican restaurant.

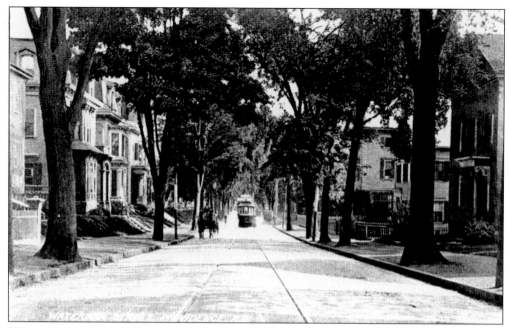

WATERMAN STREET. Waterman Street is one of the main streets running across the East Side and connecting downtown with points east. The trolleys ran on Waterman Street until the East Side Tunnel was built. Waterman Street has long been a fashionable address, and large, stylish houses were erected here by businessmen and professionals in the years after the Civil War.

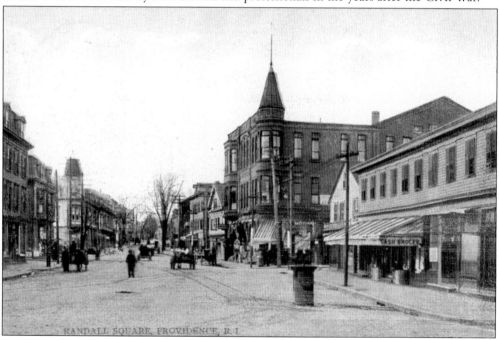

RANDALL SQUARE. As it is seen here, the square is just a memory. The whole section was leveled in the late 1960s and early 1970s. The square was centered on Randall and Charles Streets. The area was cleared to make way for redevelopment. As can be seen by some of the impressive buildings in this view, it was a thriving area at one time.

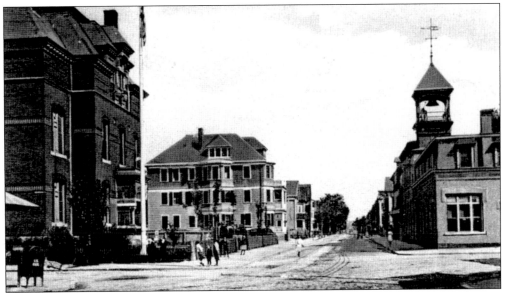

SMITH HILL. The Candace Street School is the brick building on the left at the corner of Orms and Candace Streets. The school, no longer standing, dated from 1877. To the right of the school is a three-story tenement, one of many found in the Smith Hill neighborhood. They were built to provide housing for the many families of various ethnic groups that flocked to the area. On the right is the Steam Engine Company No. 12 building. This fire station, erected in 1875, was destroyed long ago.

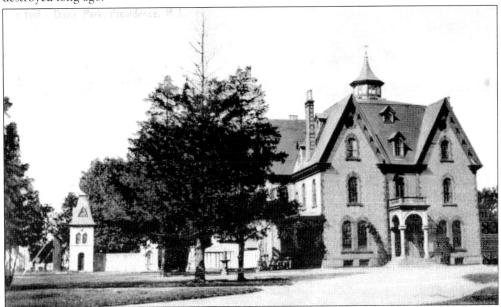

THE THOMAS DAVIS HOUSE. This home was built in 1869 at the corner of Chalkstone Avenue and Raymond Street in the Smith Hill section. Davis, an Irish immigrant, made a fortune in the jewelry business in Providence and became active in the state political scene. Elected to the U.S. House of Representatives in 1852, he was the first of his countrymen to represent Rhode Island there. Upon his death in 1891, this house and the grounds were left to the city, and Davis Park has remained an important part of the city's recreational facilities. The house was demolished.

HAYWARD PARK. The park was named after William S. Hayward, Providence mayor from 1881 to 1884. Hayward was head of the Union Trust Bank and the Citizens Savings Bank. The park no longer exists, as it was destroyed when the intersection for Interstates 95 and 195 was put into place. The nearly two-acre park was previously called Sixth Avenue Park and was on the site of the old West Burial Ground, which was moved in 1889. The park and its 25 ½-foot fountain were dedicated on September 25, 1889.

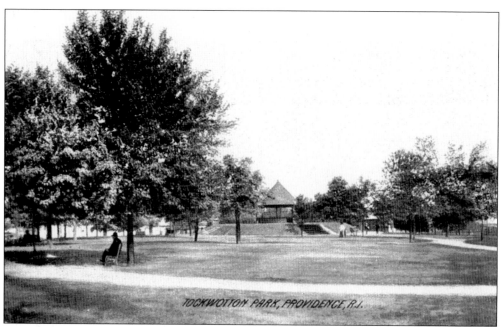

TOCKWOTTON PARK. Located in the Fox Point neighborhood of Providence, the area surrounding the park was the site of a hotel that opened on Tockwotton Hill in 1836. It was popular because of its waterfront location. The hotel was later used as a reform school from 1850 to 1880. The building was destroyed in 1889, and the city built Tockwotton Park, a pleasant open space for neighborhood residents. Today, a school is on the site.

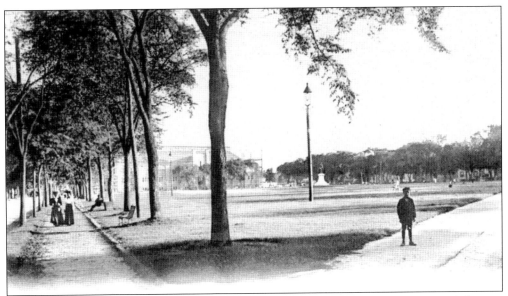

The Dexter Training Ground, Westminster Street. The training ground dates to 1824 when Ebenezer Knight Dexter left a farm of 10 acres to the city to be used as a military training field. Following President Lincoln's request in 1861, Governor William Sprague called for volunteers for the army. Answering the call, hundreds of men organized at the training ground before departing for battle. The military used the ground into the 20th century, and today it is still an open green. The Cranston Street Armory stands in the distance.

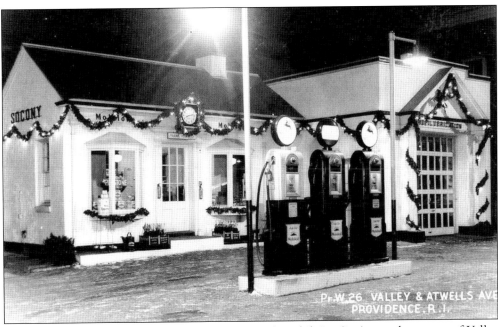

Mobil Gas Station. This beautifully maintained Mobil Gas Station at the corner of Valley Street and Atwells Avenue is decorated for Christmas. Frank Hawkins was the proprietor, and he obviously took great pride in his station.

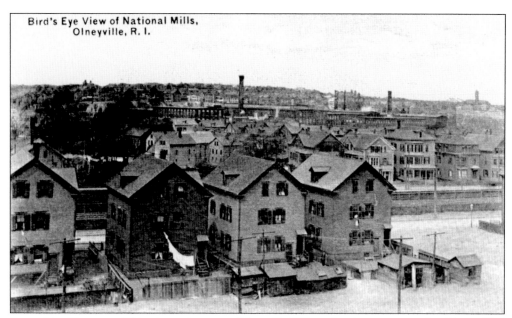

SHOO FLY VILLAGE. This view taken near "Shoo Fly Village," a tiny spot near the Olneyville/ Federal Hill boundary, shows what most mill workers saw every day— rows of crowded tenements with their tiny backyards, the railroad tracks, and the textile mills a short distance away. The tracks were the main line for the New York, New Haven and Hartford Railroad, and the view looks west towards the mills on Valley Street.

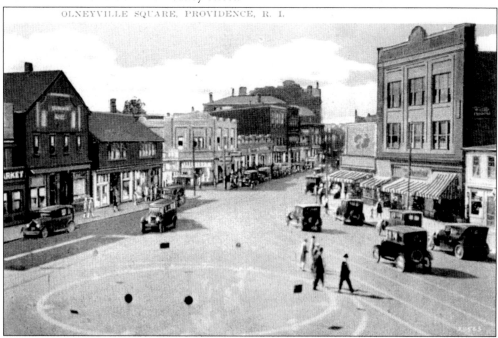

OLNEYVILLE SQUARE, 1920s. Many of the retail buildings in this important section of Providence are seen here. Immigrants flocked to the village of Olneyville to find work in the nearby textile mills and housing in the many tenements in the area. The Olneyville Square shops provided the new workers with their daily needs.

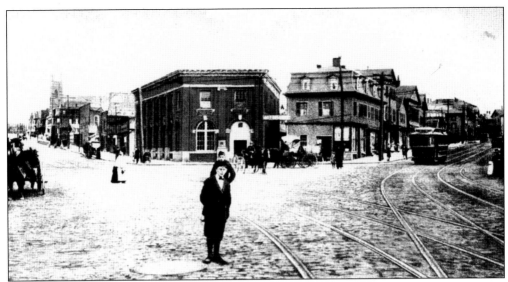

A VIEW OF OLNEYVILLE SQUARE, LOOKING EAST. Five of Providence's major streets terminate at Olneyville Square on the west side of the city. Two of these streets can be seen here: Broadway (left) and Westminster Street (right). Olneyville, named after the Olney family, developed rapidly after its beginnings in the mid–18th century. It became a transportation center, a textile center, a business center with its many stores, and a population center with housing for the new immigrants who found work here. The red brick building in the center of the image was the post office for Olneyville at that time.

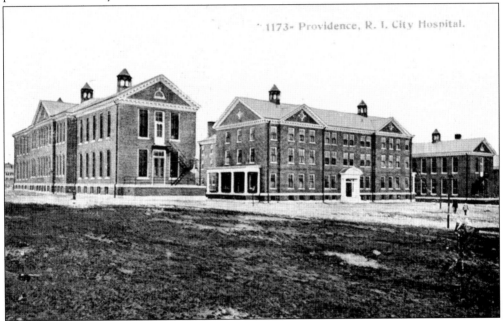

THE PROVIDENCE CITY HOSPITAL. The hospital later became the Charles V. Chapin Hospital, named after Providence's superintendent of health from 1884 to 1932. It was built on Eaton Street in 1910 by the city to house communicable-disease patients. A tuberculosis ward was added in 1912. It was built in the Georgian Revival Style on large, park-like grounds. Since 1974, the buildings have been part of the Providence College campus.

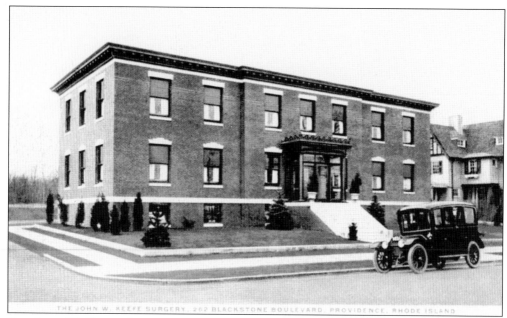

THE JOHN W. KEEFE SURGERY. Located on Blackstone Boulevard on the East Side, this small, private hospital was run by Dr. John W. Keefe. The building was constructed around 1914, and the surgery remained here until 1937, when the St. Francis Friary moved into the building. In 1973, the New England Academy of Torah, a Jewish day high school, occupied the building.

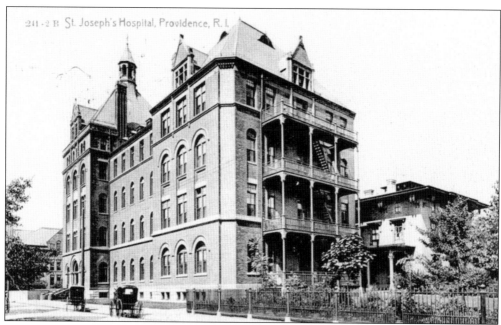

ST. JOSEPH'S HOSPITAL. Situated at the corner of Broad and Peace Streets in the South Providence section, the large building in this scene was designed by William R. Walker and Son in 1895, although the hospital was started by the Catholic Diocese in 1891 in the Cyrus Harris House on the right. In 1962, the old Harris House and portions of the 1895 building were demolished to make way for the present structure. St. Joseph's still operates as a specialty care facility.

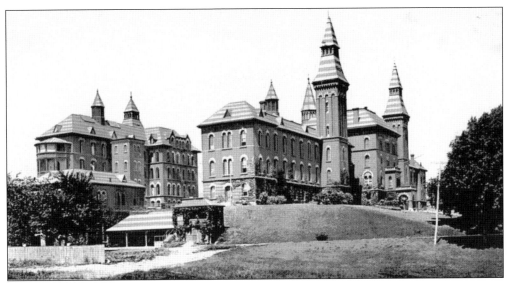

RHODE ISLAND HOSPITAL. The main building of the hospital was fully occupied in 1874, although its charter was issued in 1863. This building, along with several smaller buildings, served the needs of the community until 1900. The only building left from the original grouping is the center part, which was the Potter Children's Center. After 1900, many large gifts were made to the hospital, enabling it to expand throughout the 20th and into the 21st century. Today, Rhode Island Hospital is a major regional medical complex with over 700 beds.

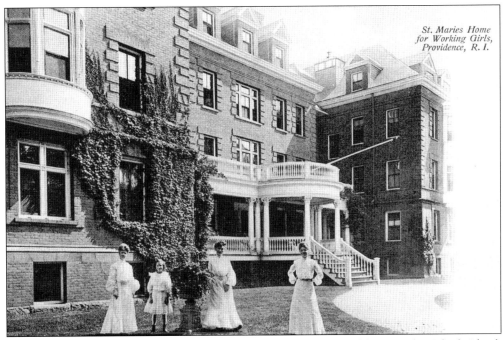

St. Maries Home for Working Girls, Providence, R. I.

HOME FOR WORKING GIRLS. Joseph Bannigan, an Irish-American rubber mogul in Rhode Island, built the large St. Maria's Working Girls' Home on Governor Street on the East Side in 1894 at a cost of $80,000. The building was constructed on the site of Governor Fenner's 18th-century house, which gave the street its name. The building has been rehabilitated as housing for the elderly.

COLUMBUS SQUARE. The square, located at the junction of Elmwood and Reservoir Avenues in the Elmwood section, is a small triangular park seen in the center of this view. Originally called Elmwood Park, it was renamed Columbus Park when the Columbus Monument was dedicated in 1895. The bronze statue was cast at the nearby Gorham foundry.

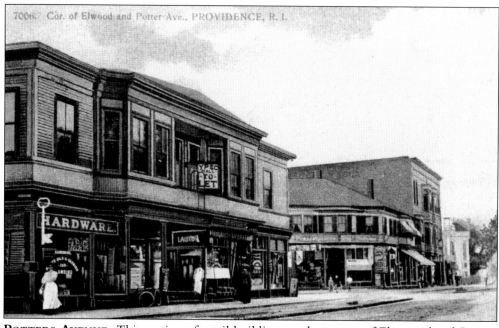

POTTERS AVENUE. This section of retail buildings at the corner of Elmwood and Potters Avenues in the South Providence section is typical of many such small clusters of businesses away from downtown that served neighborhood people. Seen here are a hardware store, a laundry, a drugstore, a second-floor hall to let, and various other businesses.

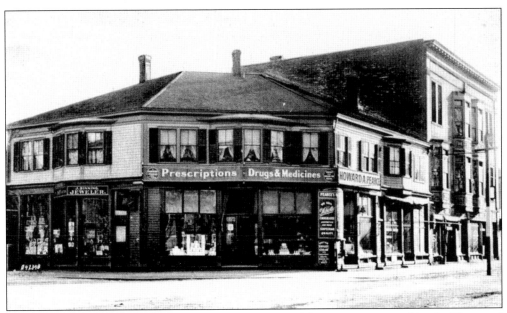

KNIGHTS OF PYTHIAS. The building in the right side of this view was owned by the Elmwood Lodge No. 16, Knights of Pythias. There were stores on the first floor and lodge rooms and flats above. The Knights were a fraternal order that was founded in 1864. In 30 years the secular group had enlisted half a million members. Their Elmwood Avenue building, built in 1897, still stands, but it is no longer used by the Knights.

NORTH BURIAL GROUND. This 150-acre cemetery was set aside in the 18th century as a militia training ground/burial ground. In the 19th century, many graves from outlying cemeteries were moved to the more fashionable North Burial Ground. Notable residents buried here are Stephen Hopkins, signer of the Declaration of Independence, and members of the prominent Brown family, probably Rhode Island's most powerful family.

FEDERAL HILL. The colorful outdoor produce markets on Federal Hill are gone, but many remember them with fondness. In the 20th century, Federal Hill was heavily populated with Italian-American residents, and many of them liked to buy their fruit and vegetables as fresh as possible. In the city, the way to do that was to buy from the sidewalk vendors who obtained a lot of their goods from local farms.

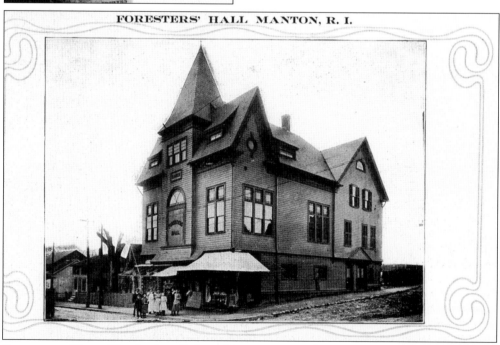

FORESTERS' HALL MANTON, R. I.

FORESTERS HALL. The Ancient Order of Foresters was a fraternal benefit society founded in 1834 that offered life and disability insurance to its members. Numerous groups with similar names split off from the main body. This hall was located on Manton Avenue near Fruit Hill Avenue in the Manton neighborhood. The building no longer stands.

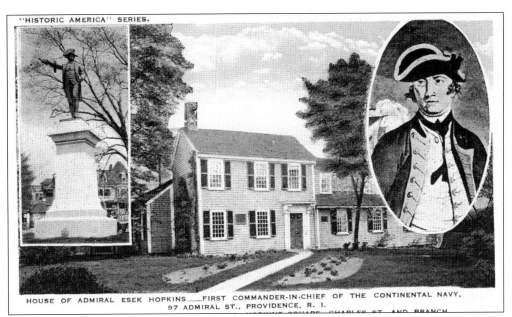

HOUSE OF ADMIRAL ESEK HOPKINS——FIRST COMMANDER-IN-CHIEF OF THE CONTINENTAL NAVY,
97 ADMIRAL ST., PROVIDENCE, R. I.

ESEK HOPKINS. Esek Hopkins achieved fame in 1775 as the first commander-in-chief of the newly created American Navy. This building was his home from 1756, when he built the gambrel-roof portion of the dwelling, to his death in 1802. In 1908, the house, located at 97 Admiral Street, was given to the city, which still owns it. The statue is located in Hopkins Park at the intersection of Charles Street and Branch Avenue. His remains are still buried there.

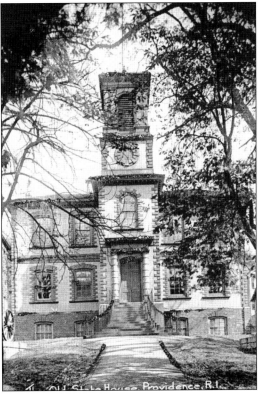

THE OLD STATE HOUSE, 150 BENEFIT STREET. The original part of this East Side building dates to 1762. Additions were made from 1850 to 1851 (Thomas Tefft, architect) and in 1867 (James Bucklin, architect). The building replaced the 1732 Colony House, which burned in 1758. Providence and Newport shared the running of Colonial and later, state government (along with three other towns for a time) until the present statehouse was first occupied in 1900. Washington, Adams, Jefferson, and Lafayette were all received in the old statehouse.

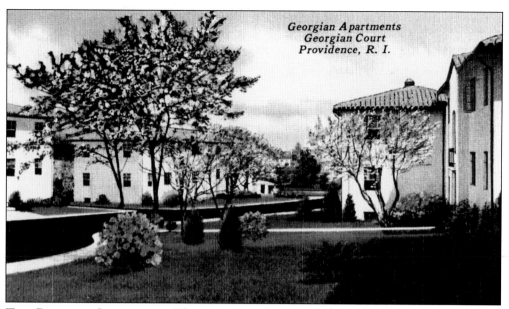

Georgian Apartments
Georgian Court
Providence, R. I.

THE GEORGIAN APARTMENTS. These apartment houses were located at 300 Killingly Street on the extreme west side of Providence. This was an advertising card for these apartments, which had just been completed (1930s). On the back is printed: ". . . they contain all the most modern conveniences including picnic grounds and parking facilities exclusively for tenants."

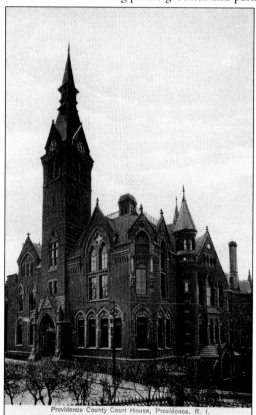

Providence County Court House, Providence, R. I.

THE PROVIDENCE COUNTY COURTHOUSE. Also known as the Superior Courthouse, this building was built in 1877 at the corner of Benefit and College Streets. It was designed in the High Victorian Gothic style by the architects Stone and Carpenter. It was replaced by the present Providence County Courthouse (1924–1933), which was built on the site of this earlier courthouse.

Three

RELIGION AND LEARNING

THE CHURCHES AND SCHOOLS

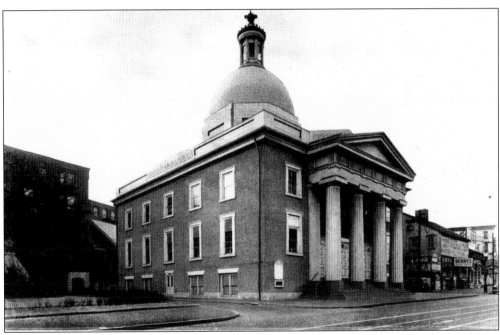

THE BENEFICENT CONGREGATIONAL CHURCH, WEYBOSSET STREET. The church was built in 1809 by Barnard Eddy and John Newman, the architect-builders, although the congregation was established in 1743. The wonderful Greek Revival portico and the gold-leafed dome dominate this important Providence landmark. Popularly called the "Round Top Church," its congregation is very active in Providence's inner-city life.

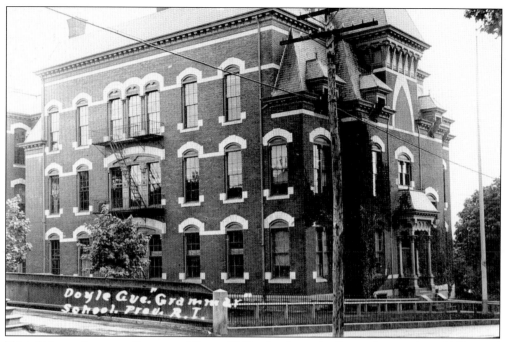

THE DOYLE AVENUE SCHOOL. The *c.* 1870 school was built to educate the middle- and working-class children of the neighborhood on the east side of Providence. Doyle Avenue runs east and west across the East Side. The building no longer stands.

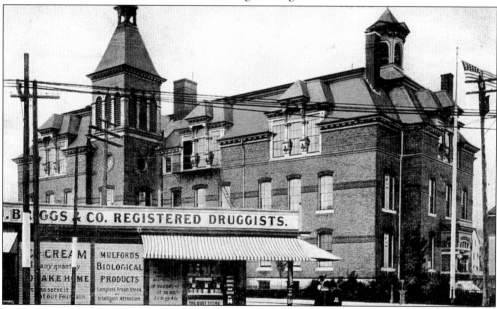

THE CANDACE STREET SCHOOL. The school was located at the corner of Smith and Candace Streets in the Smith Hill section. The original section of the school, the right-hand side, was erected in 1877 to replace an earlier wooden structure, which was too small for the rapidly growing neighborhood. The high Victorian Gothic structure was designed by E. L. Angell. The Candace name came from Candace Allen, whose family owned the surrounding land. Candace was the sister of Zachariah Allen, a noted manufacturer.

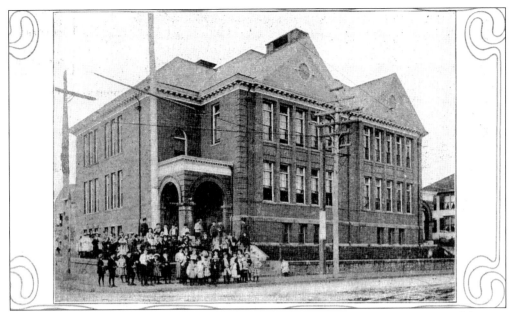

THE MANTON AVENUE GRAMMAR SCHOOL. Built in 1888 in the Manton section of the city, the six-room building was designed by William R. Walker and included much fine classical detailing. Located on the north side of Manton Avenue, a couple of blocks west of Atwells Avenue, it replaced a wooden, two-room school that was on the site before 1855. The building no longer stands.

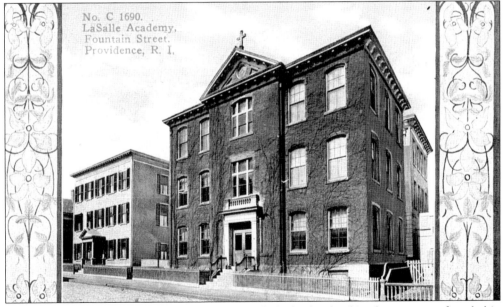

LASALLE ACADEMY. The school, the oldest Catholic high school in the state, was founded in 1871 by the Brothers of the Christian Schools. Pictured here, the school's three buildings were located downtown in LaSalle Square. The building on the left was the brothers' house and the building in the center was the first school building. The academy occupied these buildings until it moved to its present quarters at Smith Street and Academy Avenue in 1925. Originally an all boys' school, it admitted girls in 1984.

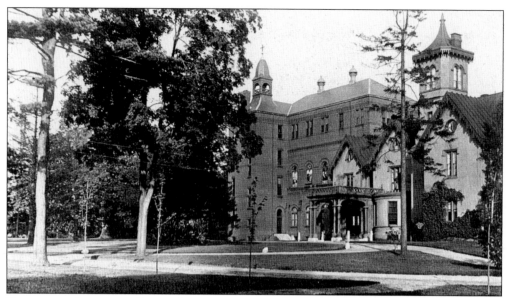

ELMHURST ACADEMY, SMITH STREET. A private Catholic girls' school, Elmhurst Academy was situated on Smith Street in the Elmhurst section. The wonderful Gothic Revival building at the right started out as the villa of Dr. William Grosvenor. It was called Elmhurst, and it gave its name to the area. In 1870, the estate became the Elmhurst Academy of the Sacred Heart. The academy left the city in 1961. In 1966, Providence College purchased the property and sold it off to the City of Providence in 1975. All the buildings have been razed, and the site is now occupied by condominiums.

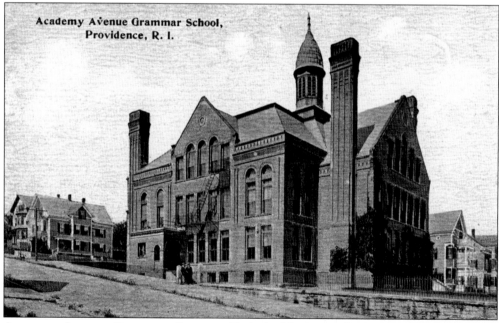

ACADEMY AVENUE GRAMMAR SCHOOL. Typical of the large schools erected in the late 19th century in Providence, the Academy Avenue Grammar School was sited one block in from Atwells Avenue. Its size reflects the large number of working-class families that lived in the neighborhood. It was torn down in the late 20th century.

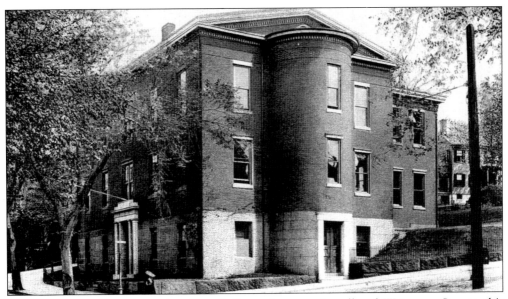

HIGH SCHOOL. Once located on Benefit Street between Angell and Waterman Streets, this building wore a number of hats and played an important role in the city's history. It was initially used as the city's first high school in 1843. The Rhode Island Normal School moved here in 1871. In 1898, it became the Rhode Island Supreme Court Building. It also served as the Rhode Island College of Pharmacy and was last used as a state social service building. It was torn down in the late 1950s, and the land is now owned by the Rhode Island School of Design.

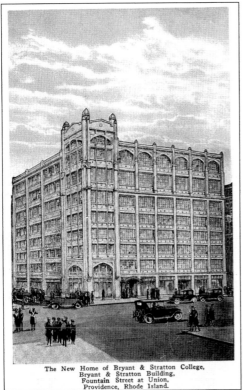

The New Home of Bryant & Stratton College,
Bryant & Stratton Building,
Fountain Street at Union,
Providence, Rhode Island.

GARDNER BUILDING. This view shows the building that still stands on Fountain Street in the downtown area. It was built around 1918 by Nathan L. Gardner, president of R. L. Greene Paper Company. The building was expanded and renovated in 1925 when Bryant and Stratton Business College occupied the building. The Providence branch of the college was organized in 1863, with rooms in the Howard Building. It later moved to the Hoppin Homestead Building on Westminster Street and then to the Butler Exchange. The college still exists, now known as Bryant University, but is no longer located in Providence.

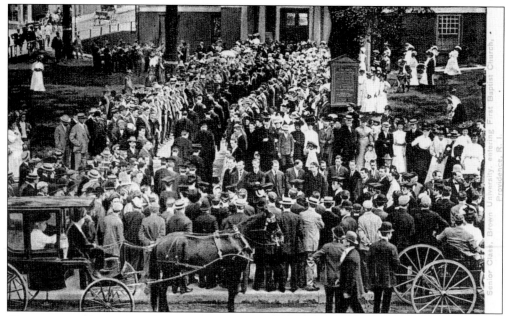

GRADUATION EXERCISES. Brown University's graduation exercises, pictured here, are still held at the First Baptist Church on North Main Street. The original plan for this church called for a smaller building, but authorities at Brown were successful in their request that a larger church be built so that their commencement exercises could be held there.

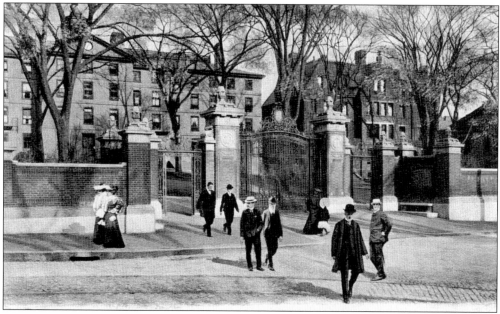

THE VAN WICKLE GATES. Seen here at the College Street entrance to Brown University, the gates were erected in 1901, and the campus was enclosed with a brick and wrought iron fence. Brown was established in 1764 in Warren, Rhode Island, as Rhode Island College. Gifts from the wealthy Brown family enabled the college to move to Providence just before the Revolution. The university maintains its place today as one of the elite schools in the country.

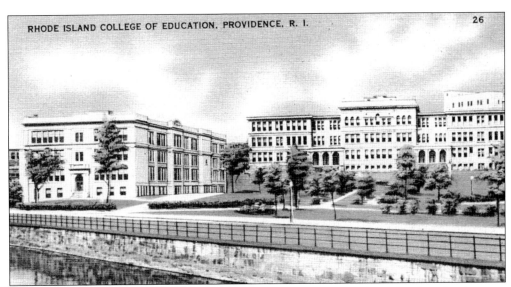

THE RHODE ISLAND COLLEGE OF EDUCATION (1898). Seen on the right, the school was set back from Promenade Street and built on the site of the old state prison. The Normal School was chartered in 1854 to train teachers. In 1920, its name was changed to the Rhode Island College of Education. In the late 1950s, the school moved to its new campus at 600 Mount Pleasant Avenue, and has been known ever since as Rhode Island College. The Normal School building and the Henry Barnard School Building (on the left) were torn down in the 1990s to make space for the Providence Place Mall.

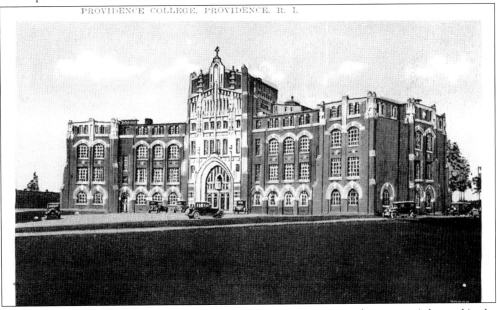

PROVIDENCE COLLEGE, PROVIDENCE, R. I.

PROVIDENCE COLLEGE. Founded by the Dominican Order in 1917, the campus is located in the Mount Pleasant/Elmhurst section. Harkins Hall, pictured here, was the first building erected (1919) on the new campus, an 18-acre piece at River Avenue and Eaton Street. The college continued to expand over the course of the 20th century. Providence College later added the Chapin Hospital building and grounds, located on Eaton Street, to its campus. Established as a school for men, Providence College admitted women in 1971.

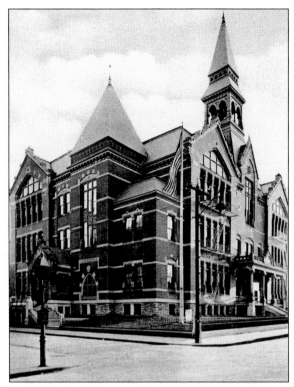

ENGLISH HIGH SCHOOL. This handsome high school building was built in 1877 at a cost of $217,000. It was referred to as the High School or as the Central High School. It was later known as English High School, at a time when there was also a Technical High School and a Classical High School. This new high school, now demolished, and a number of new neighborhood elementary schools were necessary because annexation and immigration had swelled enrollment.

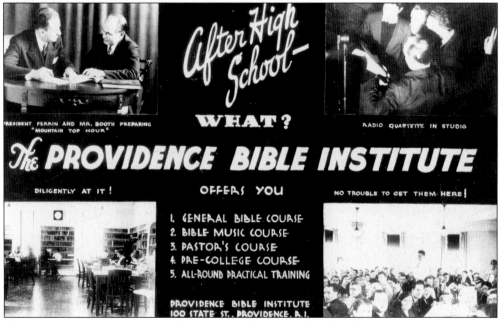

THE PROVIDENCE BIBLE INSTITUTE. Starting out as the Evening School of the Bible, the Providence Bible Institute name was first used in 1929 when the school moved to Providence from Dudley, Massachusetts. From 1950 until 1960, the institute ran campuses in Providence and Barrington. In 1960, the Providence campus closed and the school became Barrington College, which later merged with Gordon College.

THE VINEYARD STREET SCHOOL. The school, also known as the Elmwood Grammar School, was built between 1882 and 1883 from designs by William R. Walker and Son, architects. This Queen Anne structure was originally an intermediate school for graduates of primary schools in the area. It later became an elementary school. A wing on the north side was added in 1913.

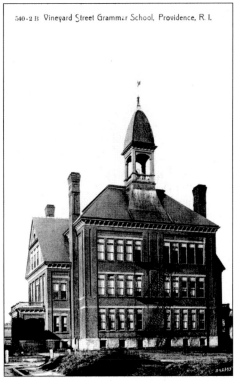

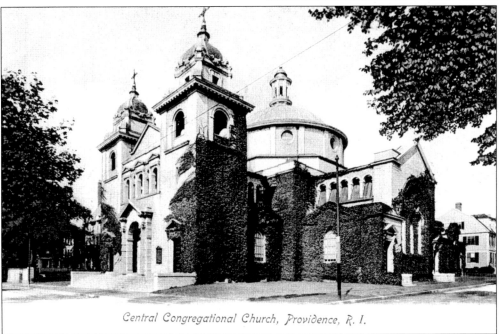

Central Congregational Church, Providence, R. I.

THE CENTRAL CONGREGATIONAL CHURCH. Located on Angell Street, the church dates from 1893. It is a Renaissance-style, domed church faced in beige brick. The elaborate entrance has twin towers with cupolas. The interior is richly decorated with tile vaults, mosaics, and stained-glass windows. The congregation is still active.

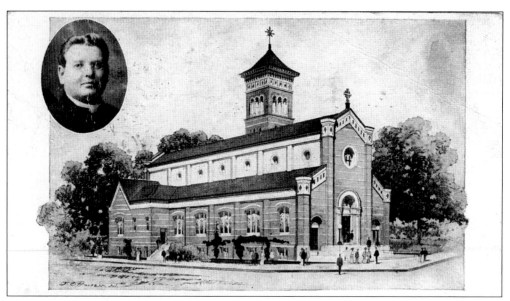

St. Ann's Roman Catholic Church. Situated on Hawkins Street in the North End of the city, the church, still active, attracted immigrants from Italy who began to arrive in the North End in the 1880s. Rev. Anthony Bove, pictured here, organized St. Ann's Parish in 1895 for the Italian-American community, and in 1910, this church was built. The architects for this Italian Romanesque building were Murphy, Hindle, and Wright, and the church is notable for its elaborate, carved-stone trim.

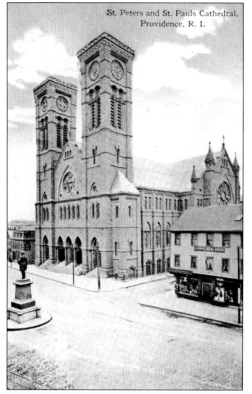

The Cathedral of Sts. Peter and Paul, 1878. The church is located at the intersection of Westminster and Weybosset Streets. In the 1970s, the area surrounding the cathedral was redesigned, and the building now faces an open plaza. Providence was designated a diocese in 1872, and this church was built to serve the diocese and the many Irish and Italian immigrants that lived in the surrounding area. The handsome design of the building, both interior and exterior, is the work of architect Patrick C. Keeley.

THE FIRST BAPTIST MEETINGHOUSE, 1775.
Built from designs by Joseph Brown, one of the four famous Brown brothers, it is considered one of the city's most important 18th-century architectural achievements. For his design, Brown drew heavily on the work of the English architect James Gibb. This is the third meetinghouse erected by this congregation, and it is considered the "mother church" of the Baptist Church in America. The building was made bigger than needed so that Brown University could hold its commencement ceremonies here.

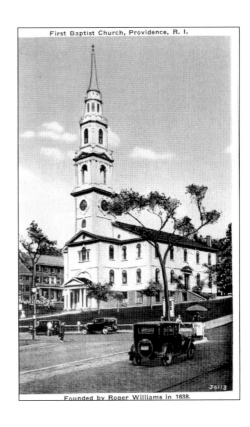

First Baptist Church, Providence, R. I.

Founded by Roger Williams in 1638.

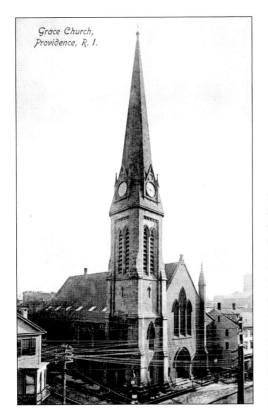

Grace Church,
Providence, R. I.

GRACE EPISCOPAL CHURCH. Located at Mathewson and Westminster Streets, the church was built between 1845 and 1846 from designs by Richard Upjohn, the foremost ecclesiastical architect in America. Grace Church was the first asymmetrical Gothic Revival church in our country. There are several Tiffany stained-glass windows inside. Notice the many electric wires in this 1905 view (all electric wires are buried in the downtown area now) and Lathrop's Providence Museum on the right (opened as the Dime Museum in 1885). In 1906, the museum, named the Nickel Theatre, became the city's first full-time movie house.

1859 ～ Golden Jubilee ～ 1909

1859 1909 1868

ST. MICHAEL'S CHURCH. Construction started on the present church on Oxford Street in South Providence in 1909. The English Norman style church, pictured in the center, was completed in 1915. The congregation became a full parish in 1859 and met in the wooden building pictured on the left. In 1868, a new brick church, shown on the right, was built to serve its Irish-American congregation, which became the largest in Rhode Island. In modern times, the congregation has shifted to a population of Hispanic and Asian Americans.

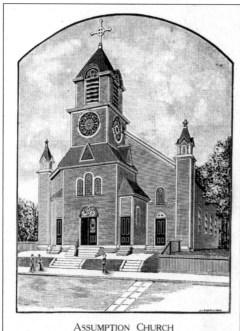

ASSUMPTION CHURCH
PROVIDENCE, R. I.

Re-union and Lawn Fete

LABOR DAY, 1909.

CHURCH OF THE ASSUMPTION OF THE BLESSED VIRGIN MARY. Completed in 1871 at 805 Potters Avenue in the Elmwood section, this church was erected to serve Elmwood's large Irish population, which began to settle here in the 1850s. Until Assumption Church was built, the Irish had to travel to St. Mary's Church on Broadway in the West End. This Gothic Revival building served as church for the parish until 1912, when the present Church of the Assumption was completed. The old church was then used as a parish hall until it was torn down in the 1970s.

THE CHURCH OF THE BLESSED SACRAMENT.
The church, located on Academy Avenue in the Mount Pleasant section, dates to 1897 and was built of red brick, terra cotta, and brownstone in a North Italian, Romanesque style. Its bell tower rises 136 feet. The stained-glass windows were designed and built by John LaFarge, the most talented stained-glass artist of late 19th-century America. Its impressive interior detailing and its beautiful exterior added together make this one of the finest examples of church architecture in Providence.

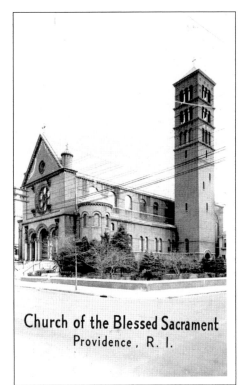

Church of the Blessed Sacrament
Providence, R. I.

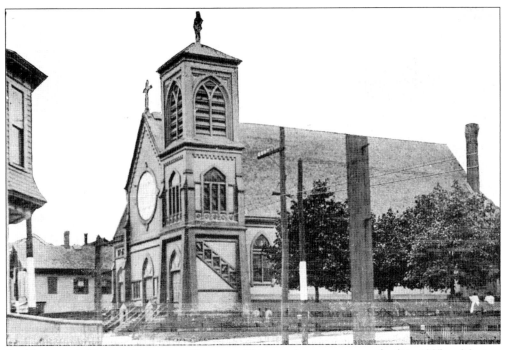

ST. THERESA'S ROMAN CATHOLIC CHURCH. This wooden structure was built in 1885 on Manton Avenue not far from Olneyville Square. The parish was formed from parts of St. Mary's and St. John's. The building was replaced in the 20th century by the present brick church building.

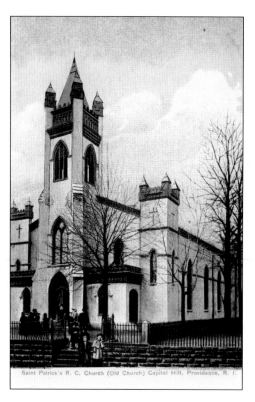

Saint Patrick's R. C. Church (Old Church) Capitol Hill, Providence, R. I.

ST. PATRICK'S CHURCH. The second Roman Catholic church built in Providence, St. Patrick's was erected in 1842 at the corner of Smith and State Streets on Smith Hill. Designed by prominent Rhode Island architect Russell Warren, it served the largely Irish population of the neighborhood. The second St. Patrick's Church was built in 1916 on the site of the earlier church. The second church was demolished in 1979.

Calvary Baptist Church
PROVIDENCE, R. I.

was organized December 28, 1854, as the Friendship Street Baptist Church. The present Chapel was dedicated in December 1897; the Temple, February 1907. Pearl Street Church united with Calvary 1918.

The following ministers have served the church:

EARL HOLLIER TOMLIN

Rev. Arthur H. Stowell 1855-1857
Rev. Moses H. Bixby 1857-1860
Rev. Wm. S. McKenzie 1861-1866
Rev. S. S. Parker 1867-1877
Rev. Edwin P. Farnham 1877-1883
Rev. Edward Mills 1883-1886
Rev. Edward Holyoke 1886-1931
Rev. Marion E. Bratcher 1919-1928
Rev. Earl Hollier Tomlin 1928—

THE CALVARY BAPTIST CHURCH. This yellow brick, neo-Gothic church is situated at 747 Broad Street in South Providence. The congregation was established in 1854 as the Friendship Street Baptist Church and met in a building on Friendship Street until moving here in 1898. They changed their name to the Calvary Baptist Church at that time. The church was dedicated in 1907. The postcard presents us with a handy list of ministers through the late 1920s.

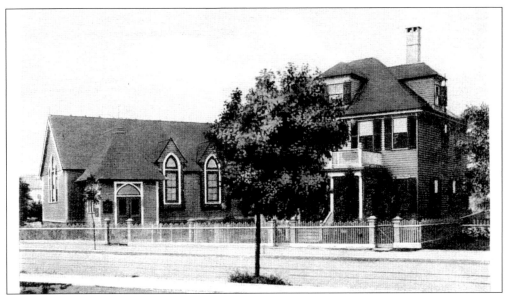

St. Paul's German Evangelical Lutheran Church. The predecessor of this church was founded in 1866 to serve the city's German residents. In 1899, St. Paul's, an outgrowth of the earlier church, built this clapboard and shingle, Gothic-style church at Union Street and Huntington Avenue in the Elmwood section. The word "German" was dropped from the congregation's name in 1932, and St. Paul's completed its present stone church in 1939. The 1899 building no longer stands.

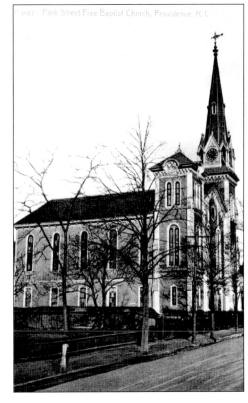

The Park Street Free Baptist Church. The congregation organized around 1850, and this building at Park and Jewett Streets was dedicated in 1868. In 1912, they joined with the Jefferson Street Baptist Church to form the United Baptist Church. The building no longer stands.

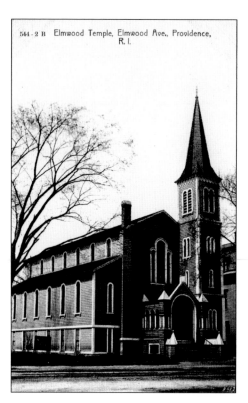

544-2 B Elmwood Temple, Elmwood Ave., Providence, R. I.

THE ELMWOOD TEMPLE. Starting life as a Congregational church in 1851 on Elmwood Avenue in the Elmwood neighborhood, its original small building was moved to Elmwood Avenue and Burnett Street in 1867 and enlarged there. The building pictured here is what the building looked like at that time. The Congregational church used the building until 1912 when it merged with the Elmwood Christian Church. This building was demolished in 1914.

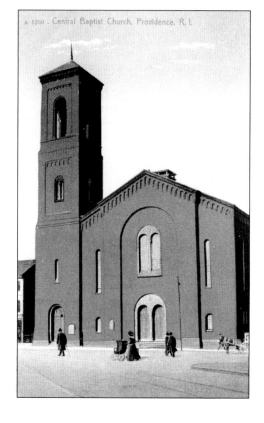

A 1280 - Central Baptist Church, Providence, R. I.

THE CENTRAL BAPTIST CHURCH. The church was formed in 1805 by a group from the First Baptist Church of Providence. They met at various places until 1857 when they occupied this church at Broad and High (now Westminster) Streets in downtown Providence. The parish remained here until they moved to Lloyd and Wayland Avenues on the East Side. This building was razed many years ago.

Four

ALONG THE SHORELINE

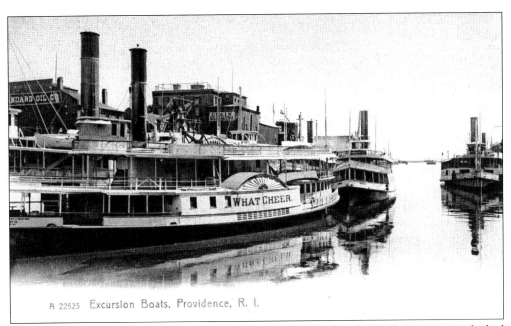

A 22523 Excursion Boats, Providence, R. I.

A VIEW LOOKING SOUTH DOWN THE BAY. The steamers *What Cheer* and *Squantum* are docked in the foreground. The words "what cheer" are seen quite often around Rhode Island. As legend tells us, "What Cheer, Netop" was the greeting that was used by the Narragansett Indians when Roger Williams landed on the west bank of the Seekonk River in 1636.

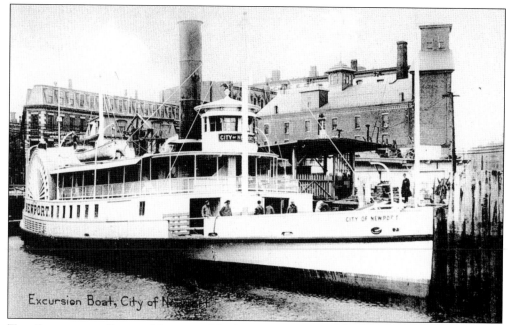

THE STEAMBOAT *CITY OF NEWPORT.* The boat is tied up along the Providence waterfront. The building with the mansard roof to the left still stands, but the brick building to the right was demolished. Trolleys, the automobile, and finally, the Great Depression finished off the steamboats.

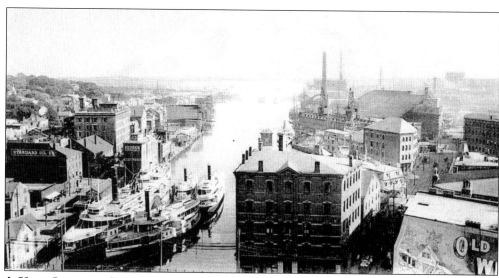

A VIEW LOOKING SOUTH DOWN TO NARRAGANSETT BAY. There are five steam excursion boats docked on the left. Most of the waterfront businesses and their buildings have vanished, as have the steamboats. This area was long neglected and only in recent times have the city and the business community come to appreciate the value of locating near the water.

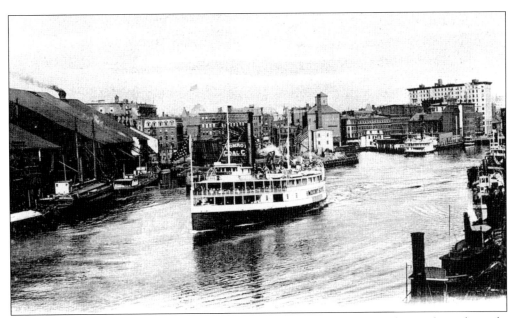

PORT OF PROVIDENCE. The coastal steamers that ran into and out of Providence brought passengers and freight to and from a number of ports from Philadelphia to Fall River. The steamboats varied greatly in size, from around 75 feet long to over 400 feet in length. The one pictured here sailing south out of Providence was a day steamer, the *Mount Hope*. It was much loved and much used, cruising Narragansett Bay for almost 57 years.

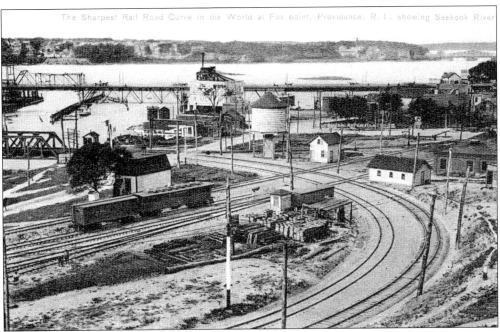

"THE SHARPEST RAILROAD CURVE IN THE WORLD." The scene shows a section of Providence on the west end of Providence's East Side. The East Providence shore is visible on the horizon, and the Washington Bridge is located just south of the railroad bridge. The trackage and land belonged to the New York, New Haven and Hartford Railroad.

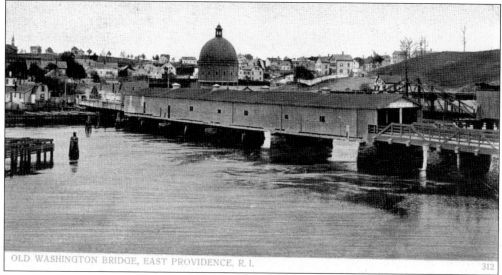

OLD WASHINGTON BRIDGE, EAST PROVIDENCE, R. I.

312

WASHINGTON BRIDGE. Five Washington Bridges have connected Providence's East Side and the city of East Providence. The first bridge was built by John Brown and others in 1793. In the early days, the bridge was called the South Bridge. This view probably shows the third Washington Bridge, and as can be seen, it was a covered bridge for part of its length. The domed structure is a gasometer on the East Providence shore.

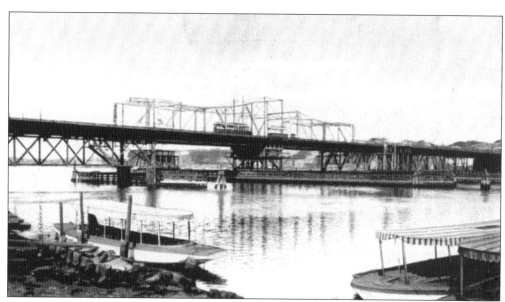

THE FOURTH WASHINGTON BRIDGE. This bridge carried trolleys as well as automobiles. It appears to have been a swing-bridge, allowing bigger boats to travel north up the Seekonk River as far as Pawtucket. Small steam launches are tied up in the foreground of the view.

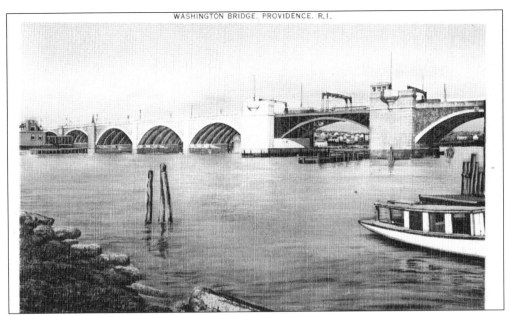

THE FIFTH WASHINGTON BRIDGE. The fifth Washington Bridge is still the main span connecting Providence with points east. Opened in 1930, the bridge is just over 2,400 feet long and has a series of 12 arches. Originally, it had a draw section, but this was disabled when a parallel span was added in 1968 to accommodate westbound motor vehicles. Today, the bridge is part of Interstate 195.

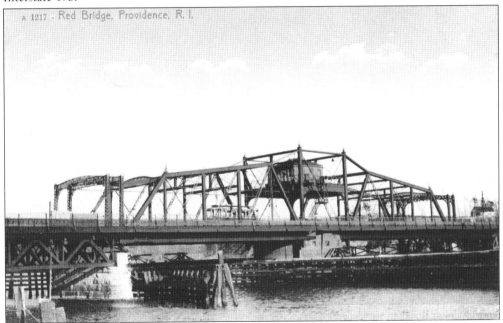

THE RED BRIDGE. Also designed to carry trolleys and automobiles across the Seekonk River, the Red Bridge is situated at a point farther north on the river. It was at the end of Waterman Street, which runs east and west across the East Side. An earlier bridge on the site was called the Central Bridge. The Red Bridge has been replaced by a steel and concrete span called the Henderson Bridge.

STARVE GOAT ISLAND. Located in the Providence River off Field's Point, the island was bought in 1863 by Robert Pettis and was said to be so barren that it could not even sustain a goat. Pettis used the island both as a base for his oyster business and as a summer retreat. Eventually, pollution killed the oysters, and the island was abandoned. From 1924 to 1938, Starve Goat Island (renamed Sunshine Island) was used to take care of undernourished youngsters who were housed there. During World War II and after, the city joined Sunshine Island to the mainland with a ring of trash.

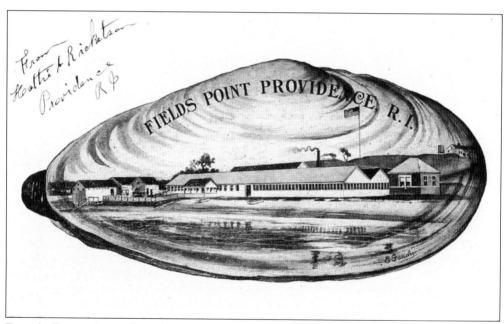

FIELD'S POINT. Located on the Providence River at Providence's southern end, Field's Point was the site of Col. S. S. Atwells's Clam House, where residents from the city and beyond could go for a sumptuous Rhode Island Clam Bake after taking the steamer from downtown. Today the sewage plant, scrap metal yards, and the like occupy the site.

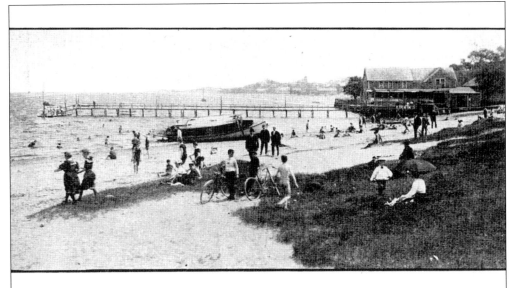

Kirwin's Bathing Beach, Providence, R. I.

KIRWIN'S BEACH. Yes, there was a bathing beach in Providence in the 20th century! John Kirwin ran this bathing beach, which was situated just south of Field's Point in Providence. It drew big crowds in the early 20th century before pollution forced it to close.

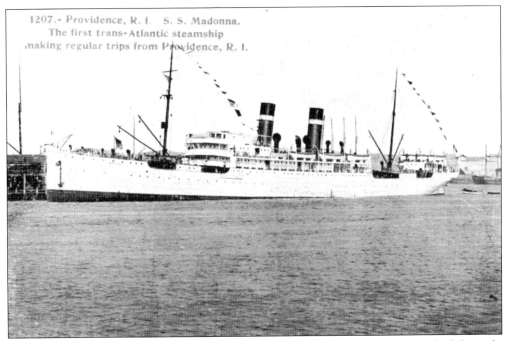

1207.- Providence, R. I. S. S. Madonna.
The first trans-Atlantic steamship
making regular trips from Providence, R. I.

THE S. S. MADONNA. The Fabre Line, based in Marseilles, operated this ship, which brought thousands of immigrants from Italy to Rhode Island after 1911. Federal Hill in Providence became one of the largest Italian settlements in the nation. Transatlantic service was suspended with the outbreak of war in 1914, though several of the Fabre ships made adventurous crossings in the following years.

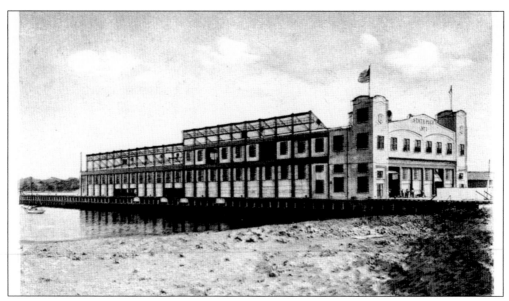

THE STATE PIER, ALLENS AVENUE. Built between 1910 and 1914, the State Pier was financed by a bond issue. It was part of the expansion of the Port of Providence south of the narrow Providence River. The facility played an important role in the aggressive campaign mounted by the chamber of commerce to draw trade to the city. The pier was a regular stop for the Fabre Line, and many Italian immigrants disembarked here in the second and third decades of the 20th century.

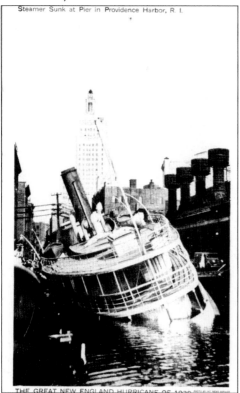

THE GREAT NEW ENGLAND HURRICANE. On September 21, 1938, the Great New England Hurricane began its sweep across New England. It wrought appalling destruction. Hitting Providence at high tide, the hurricane's tidal wave flooded downtown streets under seven feet of water, and three people drowned that day. Shipping also took a beating with the loss of ships like the *Monhegan* at its Providence dock.

Five

The Playground
of Providence

Roger Williams Park

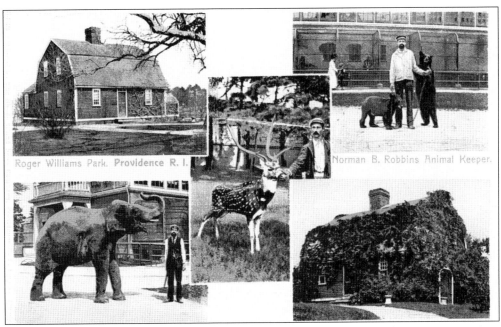

Roger Williams Park Zoo. The park and its zoo have been enjoyed by many generations of Rhode Islanders. Depicted on this *c.* 1905 postcard is animal helper Norman B. Robbins with a few of the zoo's beloved animals. The elephant was Roger, who came here in 1893 and stayed 35 years. The deer is an India Deer, donated by Perry Belmont. Robbins also maintained an active postcard concession at the park.

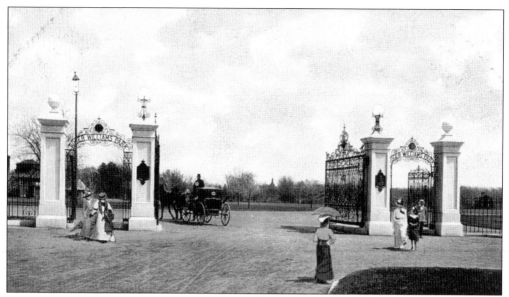

ANNA H. MAN MEMORIAL GATES. This postcard depicts the gates at the Elmwood Avenue entrance to the park. Erected in 1903, seven tons of bronze were used in making the gates, which were cast by the Gorham Company that was located not far from the park.

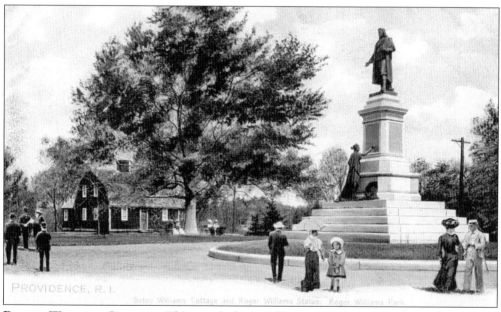

BETSEY WILLIAMS COTTAGE. This was the home of Betsey Williams, who donated a 102-acre tract to the city in 1871 that became Roger Williams Park. She was a descendent of Roger Williams, the founder of Rhode Island. Now 430 acres, the park was the first planned open space in the city. The picturesque design, with its winding roads, grouped plantings, abundant ponds, and created hills, is largely the design of Horace W. S. Cleveland. The statue of Roger Williams dates from 1877 and was required by Betsey Williams as part of the original donation agreement.

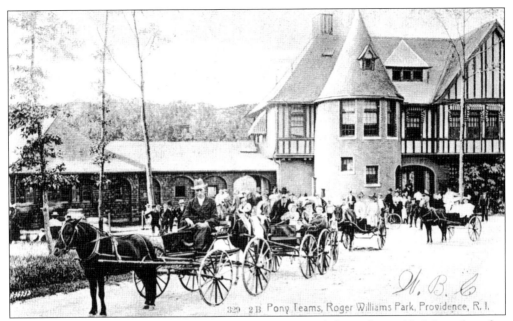

CARRIAGE RIDES. Everyone loves a ride in a carriage, and the park provided them for a fee. Ponies were used to pull a variety of carriages and carts, some woven of wicker. This *c.* 1907 photograph shows the Dalrymple Boathouse in the background. This 1896 building was where generations of fun-lovers could rent out canoes and rowboats in the old days and paddleboats in modern times.

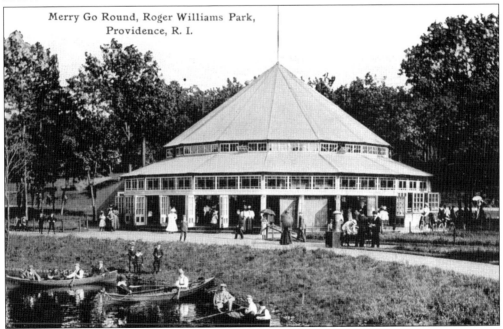

PARK MERRY-GO-ROUND. The first merry-go-round operated in Roger Williams Park in 1897. It was run by John Walker. The Williams family bought the carousel in 1929, and in 1937, they purchased a wonderful Philadelphia Toboggan carousel and installed it in the park. This carousel was removed from the park in the early 1970s and was replaced by a modern one.

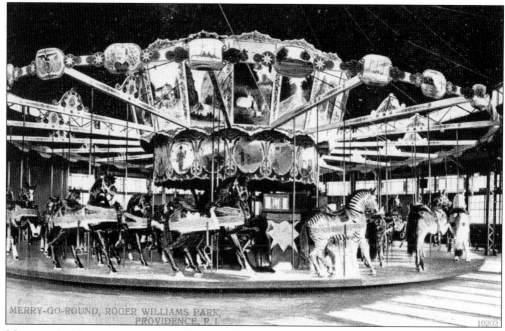

MERRY-GO-ROUND, ROGER WILLIAMS PARK, PROVIDENCE, R. I.

10202

MERRY-GO-ROUND INTERIOR. This *c.* 1910 photograph of the merry-go-round at the park shows some of the wonderful hand-carved animals that graced this 1897 carousel. Around the outer perimeter at the top of the carousel are what appear to be paintings of Rhode Island scenes.

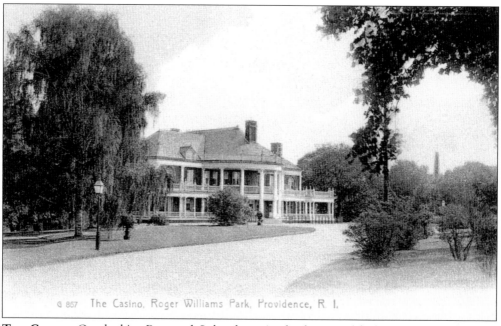

G 857 The Casino, Roger Williams Park, Providence, R. I.

THE CASINO. Overlooking Roosevelt Lake, the casino has been used for banquets and receptions since its construction between 1896 and 1897. Designed by Edward Banning, it has a lovely two-story wrap-around porch and deck. A restored banquet room is on the second floor.

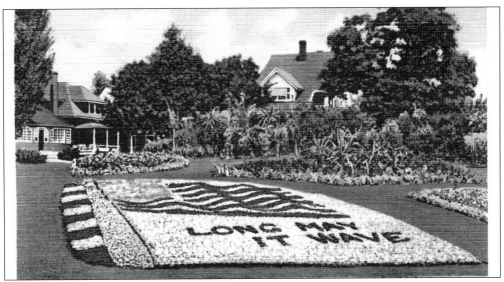

AMERICAN FLAG IN FLOWERS. Made entirely of flowers, the American flag was first laid out in 1926. Rhode Islanders loved to drive or walk by the flag and other floral displays nearby. Small hills and valleys were put in place to create a "waving" effect for the flag. In addition to the flag, there were a number of other designs made up of flowers at the park, including a floral clock, a portrait of George Washington, a tribute to the American Legion, and the "Gates Ajar." Two park workers were always on hand who could install the floral works without direction.

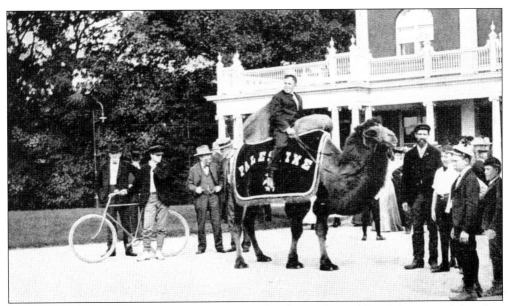

"HOLY MOSES". Holy Moses is referred to as "the Shriners' camel," so it is assumed that they donated the money to purchase the animal. The Shriners conducted services at the park, so this scene probably shows people gathered in front of the casino for one of their ceremonies. The ever-present animal helper Norman Robbins is standing just to the right of the camel.

PONY RIDE. Pony rides have been a staple at the park for many years. The young boy in this *c.* 1910 photograph has his six-shooter ready for any bad guys he may encounter.

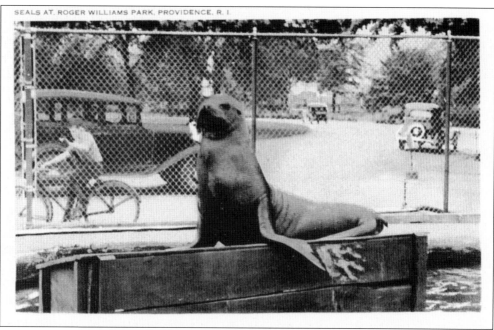

SEALS AT. ROGER WILLIAMS PARK, PROVIDENCE, R. I.

SEA LIONS. A pool was built behind the casino to house the park's sea lions. Seeing them fed was a delight for young and old. The keepers would throw the seals fish, which they usually caught in their mouths.

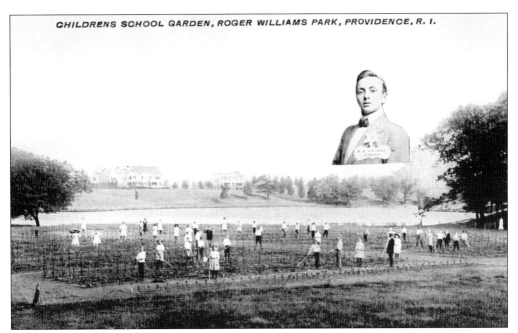

CHILDRENS SCHOOL GARDEN, ROGER WILLIAMS PARK, PROVIDENCE, R. I.

CHILDREN'S SCHOOL GARDEN. Ernest K. Thomas, pictured in the inset, was the director of the Children's School Garden at the park. Described in a 1912 state report as a model school garden, it appears to have been well organized and of a good size. Five local schools sent children there for instruction. In 1910, there were 76 individual plots, each 10 feet by 23 feet.

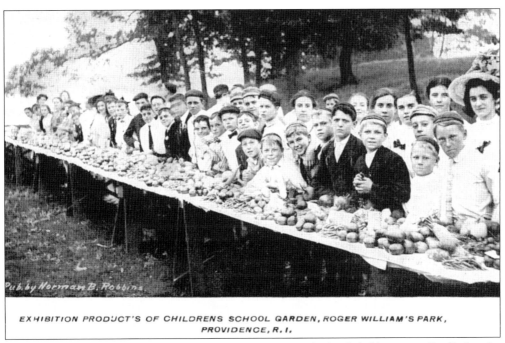

Pub. by Norman B. Robbins

EXHIBITION PRODUCT'S OF CHILDRENS SCHOOL GARDEN, ROGER WILLIAM'S PARK, PROVIDENCE, R. I.

CHILDREN WITH THEIR VEGETABLES. A happy group of school children proudly display the vegetables that they worked so hard to grow at the children's garden. A number of schools in the city had children's gardens, and they could be found in other towns throughout the state.

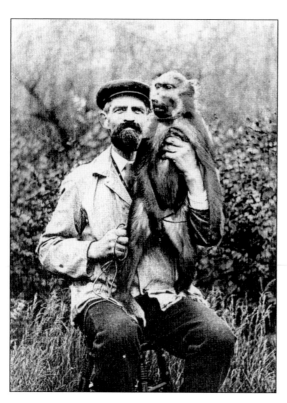

ANIMAL HELPER NORMAN B. ROBBINS. Posing around 1910 with one of the monkeys from Monkey Island, Robbins was seen at the park for many years. He also can be seen on many postcards of the park from that period.

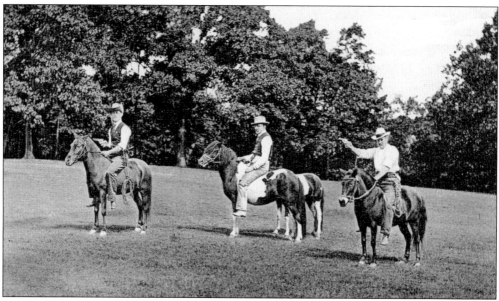

MEN AND THEIR PONIES. The purpose of this group is unknown, but they could have used some real adult-sized horses. More than likely, they were part of a sideshow for park patrons.

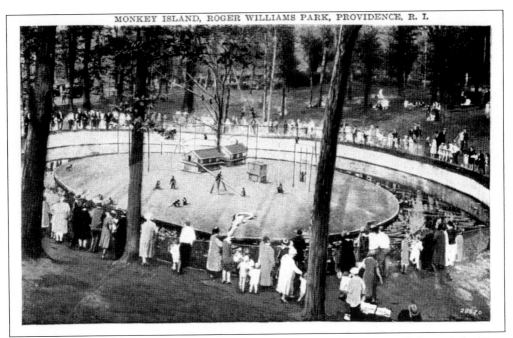

MONKEY ISLAND. Located in a ravine immediately south of Monument Lake and the Dyer Memorial was Monkey Island, which allowed visitors to view the animals unobstructed by cages. Nothing remains of the exhibit.

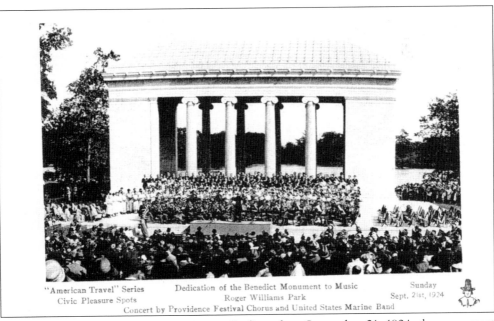

"American Travel" Series Dedication of the Benedict Monument to Music Sunday
Civic Pleasure Spots Roger Williams Park Sept. 21st, 1924
Concert by Providence Festival Chorus and United States Marine Band

THE BENEDICT MONUMENT TO MUSIC. Dedicated on September 21, 1924, the monument was intended for concerts, plays, and other assemblies. Built of Vermont marble, it was erected following the bequest of William Curtis Benedict, a local olive oil merchant.

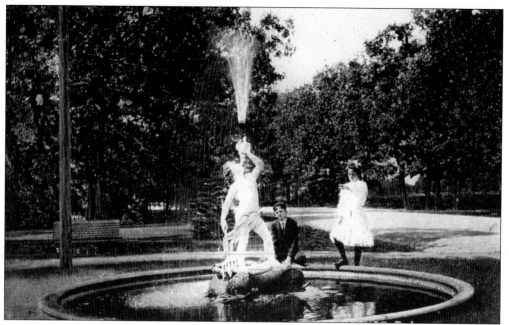

THE BROAD STREET FOUNTAIN. Two young people pose at the Broad Street Fountain, one of a few scattered throughout the park. The Broad Street entrance and the Elmwood Avenue entrance were the two main entryways to the park.

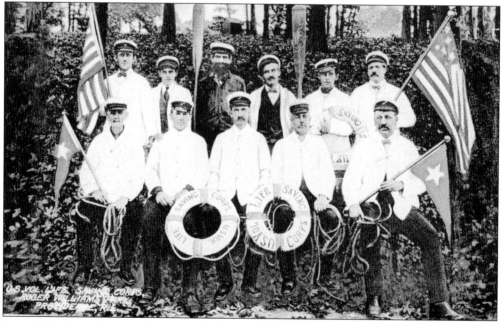

THE U.S. VOLUNTEER LIFE SAVING CORPS. The corps was a national organization that organized crews of volunteers who were taught the rudiments of life saving. Little is know of the group, but there may have been some connection with the American Red Cross Volunteer Life Savings Corps. Animal helper Robbins is the bearded gentleman in the back row.

Six

THE PEOPLE IN ACTION

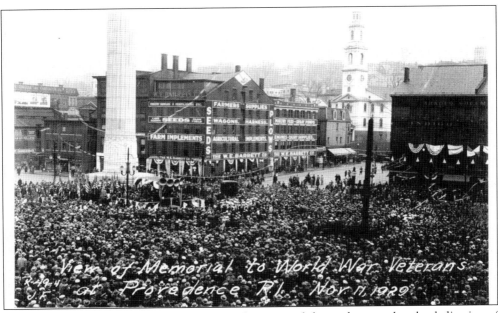

WORLD WAR I MEMORIAL DEDICATION. This postcard shows the crowd at the dedication of the World War I Memorial on November 11, 1929. The monument was erected in what was then called Post Office Square. After the dedication, it was renamed Monument Square. The 75-foot memorial commemorated the men of Providence who gave their lives during the Great War. The monument was recently moved to a small park opposite the Providence County Courthouse.

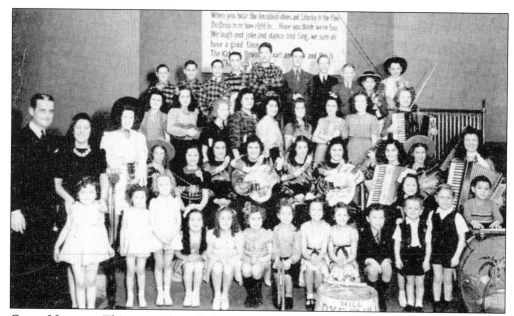

CELIA MOREAU. This postcard, mailed in 1941, was sent to a listener of the radio program *Celia Moreau and Her WJAR Kiddie Revue.* Moreau's show aired on Saturday mornings on the WJAR radio station, broadcast from the Outlet Department Store. Many local notables participated in the revue, including former mayor Buddy Cianci, long-time TV weatherman Art Lake, and radio talk-show host Maryann Sorrentino.

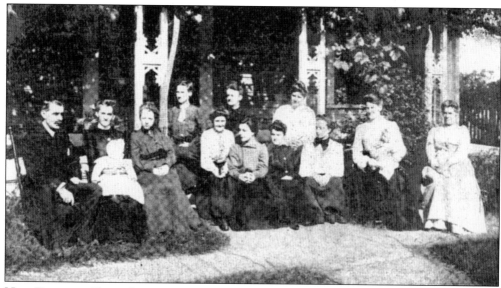

NEW ENGLAND REST COTTAGE. Rest cottages at the time of this *c.* 1905 postcard were places that took care of orphans and unwed mothers. Evidence of this is seen by the young women in the front row and the two babies. The New England Rest Cottage was located on Avon Street on the west side of Providence.

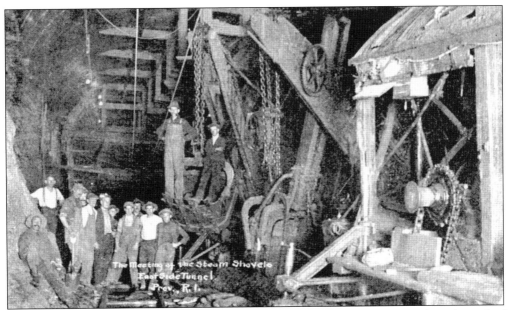

MEETING OF SHOVELS. Shown here is the meeting of the steam shovels signaling the end of excavation for the East Side rail tunnel. Construction crews had worked from both ends of the hill that forms part of the East Side of the city. One crew worked west from just off Gano Street and the other crew worked east from just off North Main Street. The tunnel linked the main railroad with the suburban rail line to East Providence, Warren, Bristol, and other points east of the city.

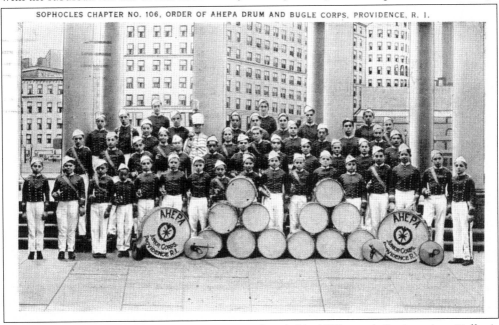

AHEPA DRUM AND BUGLE CORPS. AHEPA, founded in 1922, stands for American Hellenic Educational Progressive Association. The corps was sponsored by the Providence Chapter of AHEPA, Sophocles Chapter No. 106. In 1935, there were 55 boys, all of Greek extraction, in the corps. They ranged in age from 12 to 18 years old. The boys are posed at the front of the Providence County Courthouse.

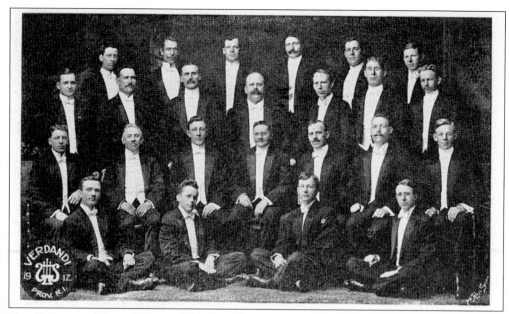

THE VERDANDI MALE CHORUS. This Providence choral group, pictured here in 1912, was drawn from the Swedish community in the city. The group still exists today, but is now headquartered at the Scandinavian Home on Broad Street in Cranston.

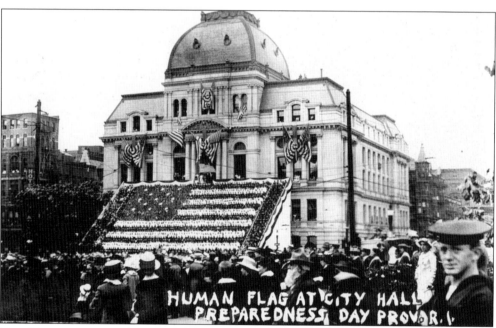

THE HUMAN FLAG. In front of city hall on Preparedness Day, June 3, 1916, is a "human flag" made up of 1,560 school children. An honor guard of Civil War veterans served as the border of the flag. Tens of thousands of people marched in the city in the accompanying Preparedness Parade. The activities were in response to President Wilson's call for readiness in support for the allied cause in World War I.

OLD HOME WEEK. Before there was television, there were parades and celebrations. Cities and towns across Rhode Island celebrated Old Home Week, which this card depicts on Weybosset Street in 1907. The purpose of the event was to bring former residents back to their hometown. The arch in the middle of the street was put up by the Outlet Company in front of their large department store. Buildings throughout the downtown area were decorated for the weeklong event.

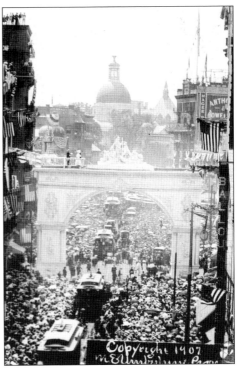

FROM THE ROYCROFT SHOP
WHICH IS IN EAST AURORA,
ERIE COUNTY, N.Y., U.S.A.

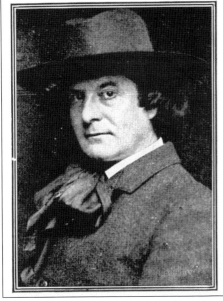

YOU are invited to attend a Lecture by Mr. Elbert Hubbard at *The Arcanum*, One Hundred & Fifty-Two Weybosset Street, Providence, Rhode Island, on Wednesday Evening, January Thirty-First, 1906, at Eight-Fifteen o'Clock. Subject: *An Age of Commonsense.*

General Admittance, One Dollar
Reserved Seats on sale at M. Steinert & Sons Co.,
Thirty-Two Westminster Street

ELBERT HUBBARD. Born in 1856, Elbert Hubbard, an author and editor, was once described as "an independently thinking man of the Progressive Era." He founded an artist colony in East Aurora, New York, where he established the Roycroft Press. The latter grew into a craft community and produced handsome books, furniture, and other Mission-Style products. Hubbard was the most sought-after lecturer in America. This postcard advertised one of his talks in Providence. He and his second wife, Alice Moore Hubbard, a noted suffragist, were killed in 1915 while aboard the *Lusitania*.

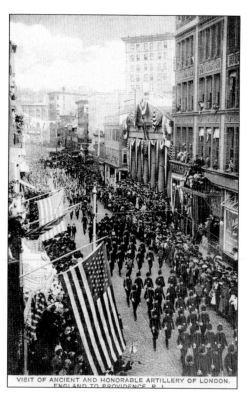

VISIT OF ANCIENT AND HONORABLE ARTILLERY OF LONDON, ENGLAND TO PROVIDENCE, R. I.

ANCIENT AND HONORABLE ARTILLERY OF LONDON. In this *c.* 1915 postcard, this ancient artillery group from London, England, marches to the delight of many spectators in Providence. The sidewalks are jam-packed with people as are many of the open windows that fronted Westminster Street. The artillery was chartered by King Henry VIII in 1537 and is considered by many to be the oldest regiment in the British Army.

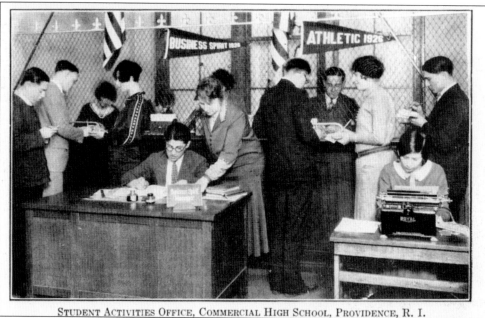

STUDENT ACTIVITIES OFFICE, COMMERCIAL HIGH SCHOOL, PROVIDENCE, R. I.

COMMERCIAL HIGH SCHOOL. In the 1890s, Commercial High School was a department of the Providence High School. In 1923, a new Commercial High School was established at Summer and Pond Streets. This postcard view shows a room inside that building in 1926. The students are honing their business skills under the watchful eye of their instructors. In 1932, Central High School absorbed Commercial High School.

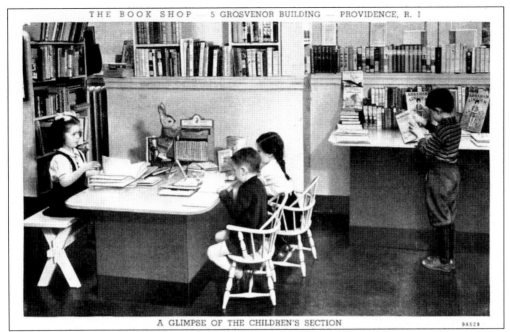

A GLIMPSE OF THE CHILDREN'S SECTION

THE BOOK SHOP. Located in the Grosvenor Building downtown, the Book Shop was both a retail store and a lending library. It advertised that it had a fine selection of children's books, as can be surmised by the sight of the contented children pictured here. The date of the postmark on this advertising postcard is 1946.

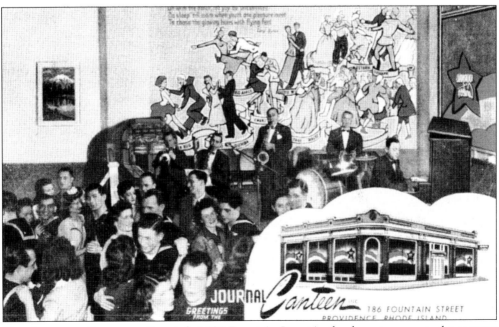

THE JOURNAL CANTEEN. Located at 186 Fountain Street in the downtown area, the canteen was sponsored by the *Providence Journal Bulletin* and dedicated to Rhode Island serviceman and women who were serving around the world. The building was constructed around 1910. Today it houses a brewpub.

FOR MEMBER OF CONGRESS
First Congressional District
DANIEL L.D. GRANGER
OF PROVIDENCE

Tried in many positions he has always been found faithful to his trust. Independent and fearless, no man controls him. His Two Terms in Congress have shown his fitness for the Position.

Rhode Island's interests are Safe in His Hands.

VOTE FOR HIM

Olney Arnold, Providence Gilbert H. Burnham, N'p't
Joseph P. Canning, " P. J. Murphy, Newport
Z. Chafee, " Geo. J. Norton, E. Prov.
 COMMITTEE

Eleven Years City Treasurer
and
Two Years Mayor of Providence

DANIEL L. D. GRANGER. Granger's reelection committee sent out postcards like this in 1906, just before the November election. Granger, "Independent and fearless, no man controls him," was elected again and served until his death in 1909.

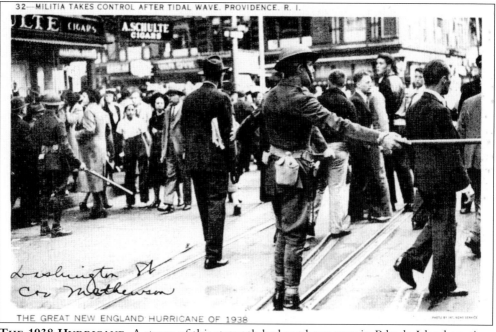

THE 1938 HURRICANE. A storm of this strength had not been seen in Rhode Island anytime in recorded history. A tidal wave submerged downtown Providence under seven feet of water. In this photograph taken at Washington and Mathewson Streets, the state militia is doing its job—maintaining order.

Seven

IT IS WHAT IS INSIDE THAT COUNTS

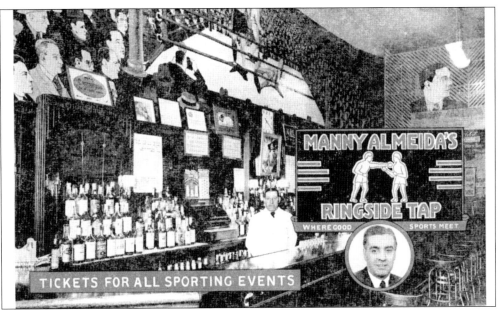

MANNY ALMEIDA'S RINGSIDE TAP. In the 1940s, the tap was located at 80 Mathewson Street in the downtown area. It was later situated at the corner of Wickenden and Brook Streets on the East Side, where it was popular with the Cape Verdean community. When Providence was a hub for boxing in New England, Manny Almeida's was a gathering place for the fight crowd. Great boxers such as Joe Louis, Rocky Marciano, and Sugar Ray Robinson passed through its doors. Almeida was the promoter for all of Rocky Marciano's 29 fights in Providence.

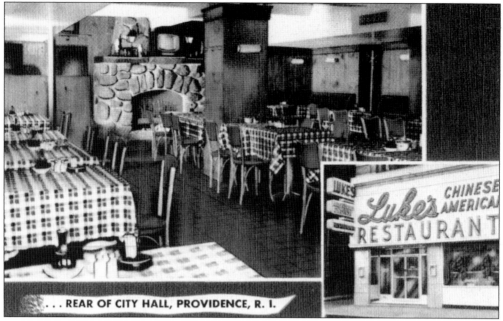

... REAR OF CITY HALL, PROVIDENCE, R. I.

LUKE'S CHINESE RESTAURANT. Long a downtown favorite, Luke's was located behind city hall at 59 Eddy Street. In later years, the restaurant also included Luke's Luau Hut, which was added downstairs. The building still stands, but the business no longer operates.

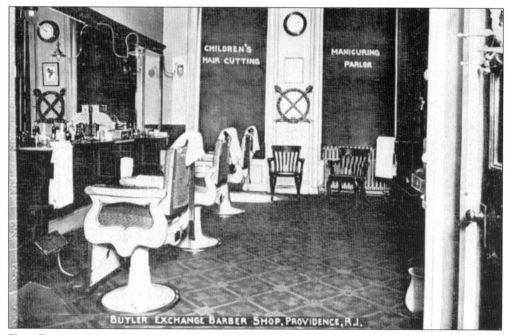

THE BUTLER EXCHANGE. Located on Exchange Place (now Kennedy Plaza), the exchange was a large 6-story retail and office building constructed in 1873. It was torn down when the Industrial National Bank Building was erected in the late 1920s. The staff at the barbershop took care of male grooming needs before the days of unisex salons.

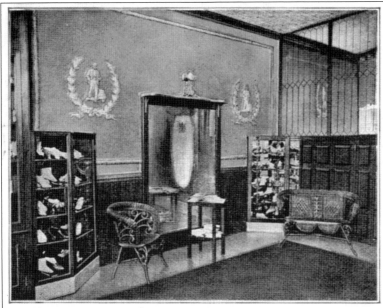

THE SIGN OF THE
HOUSE

Providence, R. I.

THE WALK-OVER SHOP, 280 WESTMINSTER STREET

THE WALK-OVER SHOP. This company had stores in cities throughout the country. Its Providence store was located in the heart of downtown at 280 Westminster Street. Its display area is quite different from what is seen in a modern shoe store.

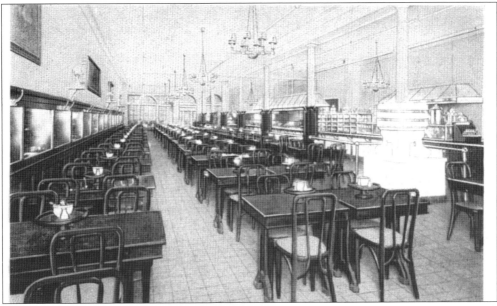

SHEPARD'S CAFETERIA. John Shepard, a radio mogul, owned department stores in Boston and on Westminster Street in Providence. The Providence store remained in the family from 1880 until 1970. The Shepard Company went bankrupt in 1974. At a Mathewson Street location nearby, Shepard ran a cafeteria, pictured here, and a Colonial Room Restaurant on the second floor. There was also a Shepard's Tea Room in the mid-20th century, where shoppers could take a break from shopping and have tea in elegant surroundings.

LOOKING FOR LOBSTERS?...HERE THEY ARE!

... Fresh from Johnson's own salt water purifying tanks at Wickford, R. I., into the famous "LOBSTER ROOM". Any one of Johnson's four dining rooms will make a hit with you. Drop in on your next trip through Providence!

JOHNSON'S HUMMOCKS SEA FOOD RESTAURANT. This fine restaurant was situated at 245 Allens Avenue. The business, started in 1905, was famous for its delicious seafood. One of its specialties was a miniature clambake tray. The business no longer exists.

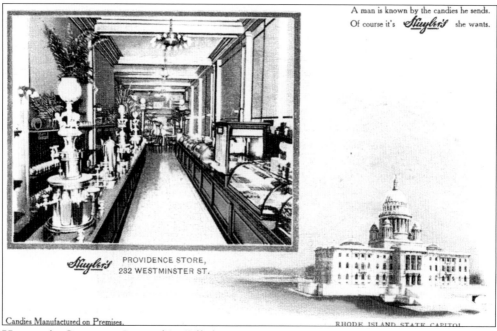

HUYLER'S CANDIES. Located in "all the important cities east of the Mississippi," Huyler's stores sold candy described as "A Token of Good Taste." Or as this postcard advertises: "A man is known by the candies he sends. Of course it's Huyler's she wants." The original family store was in Manhattan.

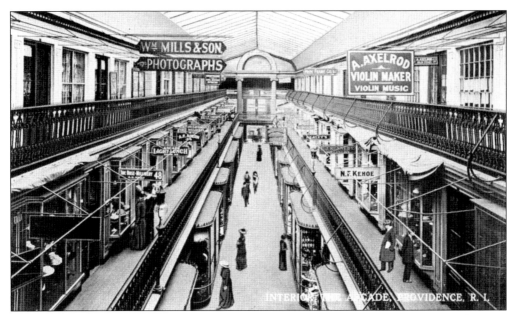

THE ARCADE. Extending between Westminster and Weybosset Streets, the arcade has two different facades, one designed by Russell Warren and the other by James Bucklin. Its original interior layout has been preserved—three floors of shops with galleries running the length of the building at each level. The arcade was the first major commercial venture on the west side of the Providence River.

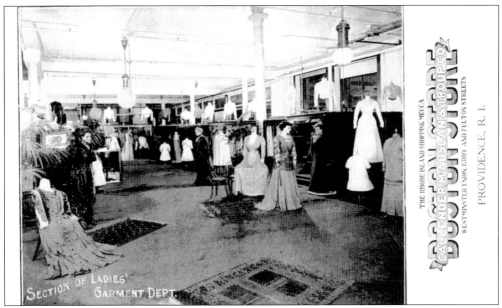

THE BOSTON STORE. A favorite of area shoppers, this 6-story brick and stone building was located at 239 Westminster Street. The business was established in 1866 as the Callendar, McAuslan, and Troup Company in a smaller building on the site. The store was successful from the onset, and expansion started in 1872. Shoppers soon started calling the store "The Boston Store" because the owners were from Boston. The Peerless Company bought out the Boston Store in the early 1950s.

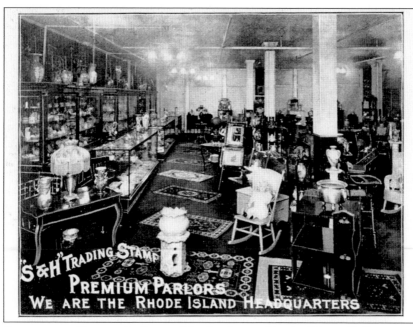

SHOPPING AT DIMOND'S. Some of the fine items offered at Dimond's Department Store, located on Weybosset Street, can be seen here. Asian ceramics, Middle Eastern carpets, wicker furniture, and goods from around the world could be purchased in the home furnishings department. It also gave out S&H Green Stamps, which were always a plus for shoppers.

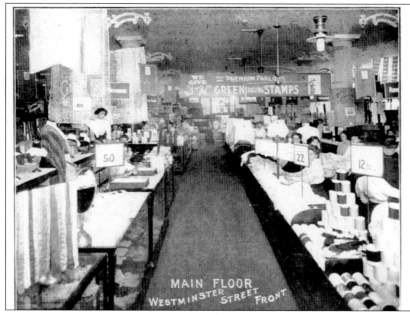

DIMOND'S DEPARTMENT STORE. On the main floor of Dimonds, ribbon, neckwear, hosiery, and toiletry items are for sale. In the back of the store, the large sign tells the shopper that the store gives out S&H Green Stamps.

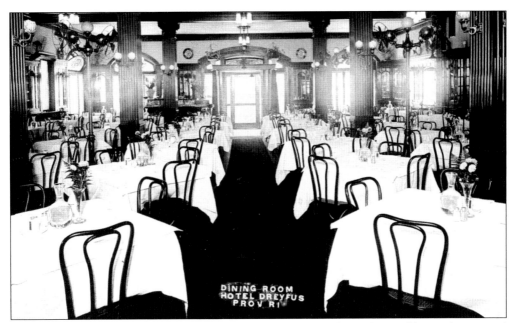

HOTEL DREYFUSS. The elegant dining room of the Hotel Dreyfuss is depicted here. The postcard was mailed in 1917, so this card might show the dining room after the 1917 renovation. The hotel was built around 1890 on Washington Street in the downtown area and was a successful hotel well into the 20th century. Today, the building is occupied by Johnson and Wales University.

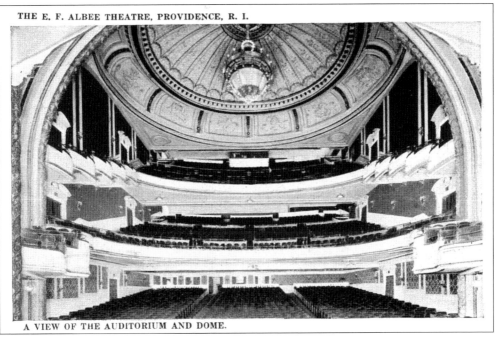

THE E. F. ALBEE THEATRE, PROVIDENCE, R. I.

A VIEW OF THE AUDITORIUM AND DOME.

THE E. F. ALBEE THEATRE. Built in 1919, the Albee Theatre was located on Westminster Street. Able to seat over 2,300 people, it was truly a picture palace. In its early days, it was advertised as the home of the Keith Vaudeville Company and the E. F. Albee Stock Company, and was also known as RKO Albee for a time.

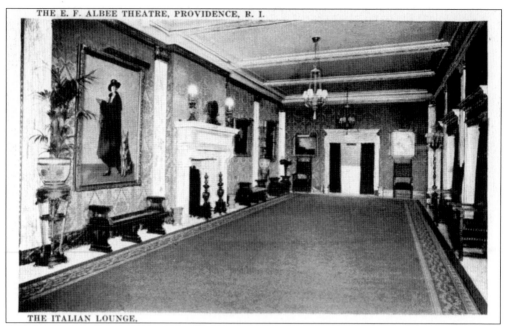

THE E. F. ALBEE THEATRE, PROVIDENCE, R. I.

THE ITALIAN LOUNGE.

THE ITALIAN LOUNGE. The E. F. Albee Theatre's Italian Lounge was sumptuous, as can be seen in this view. On the back of this 1920s postcard are printed these words: "Rhode Island's Million Dollar Play-House" and "The Most Beautiful Theatre in the World." It was a lovely theatre, but, alas, there is only a parking lot on the site today.

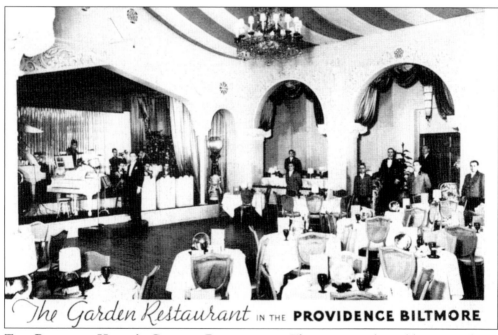

The Garden Restaurant IN THE **PROVIDENCE BILTMORE**

THE BILTMORE HOTEL'S GARDEN RESTAURANT. The restaurant hosted big name dance orchestras and floor show attractions, including orchestra leaders Benny Goodman and Jimmy Dorsey, Esther Williams's water show, and Sonia Henie's ice show. An adjoining Terrace Café permitted dining outdoors.

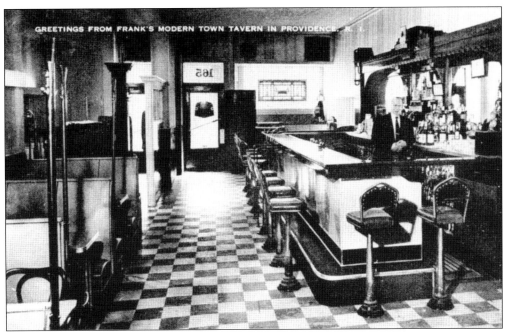

FRANK'S MODERN TAVERN. Frank's Modern Town Tavern was located at 165 Washington Street. Frank J. Joseph was the proprietor, and it can be assumed that Frank is standing behind the bar. This *c.* 1930 postcard shows a scene typical of taverns across the nation at that time.

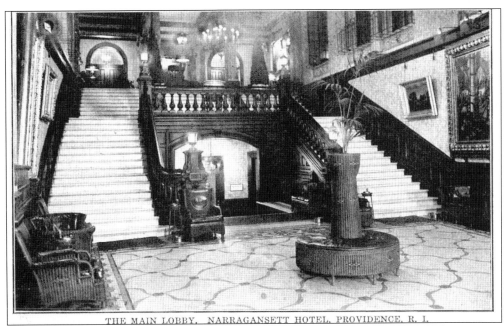

NARRAGANSETT HOTEL MAIN LOBBY. The finely furnished main lobby of the Narragansett Hotel at Weybosset and Dorrance Streets beckons in guests to this very popular establishment, which is just a memory now for the older set.

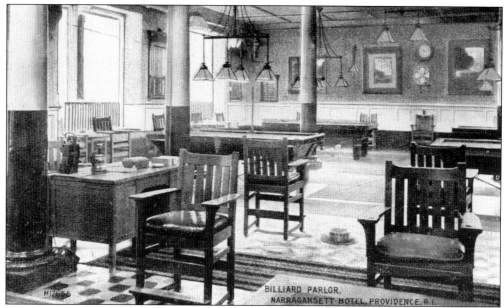

NARRAGANSETT HOTEL BILLIARD PARLOR. Located in the Narragansett Hotel, this attractive billiard parlor would have appealed to many men staying at the hotel on Weybosset Street around the beginning of the 20th century. There are both billiards tables and pool tables located in the room along with sturdy oak mission-style furniture.

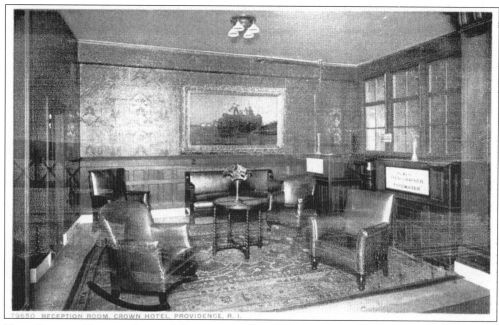

THE CROWN HOTEL. Located for years on Weybosset Street, the Crown Hotel was well appointed. This view of the reception room dates from the early 20th century, the heyday of the Crown Hotel.

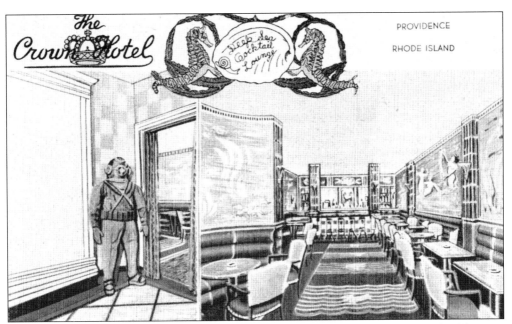

DEEP SEA COCKTAIL LOUNGE. The Crown Hotel had various restaurants and cocktail lounges over the years. One interesting lounge was the Deep Sea Cocktail Lounge, pictured here. It was described as "a unique under-sea wonderland."

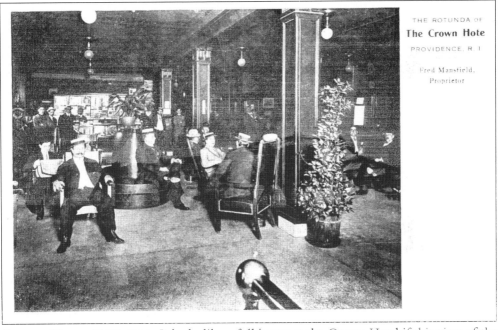

CROWN HOTEL ROTUNDA. It looks like a full house at the Crown Hotel if this view of the rotunda of the hotel is any indication. The men are dressed to the nines, with almost all of them wearing their hats. On the back of this card is the message: "This is where Papa sits and thinks of home."

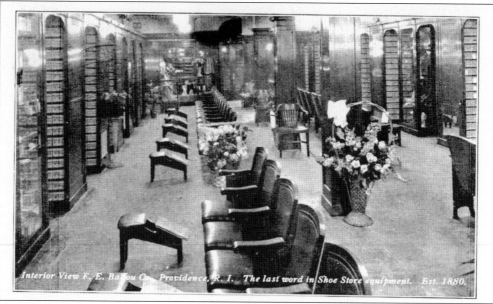

Interior View F. E. Ballou Co., Providence, R. I. The last word in Shoe Store equipment. Est. 1880.

F. E. Ballou Company. This appears to be the showroom of the F. E. Ballou Company, makers of shoe store equipment. The company dates from 1880. With all the floral arrangements in the view, this postcard may have been published at the opening of this showroom.

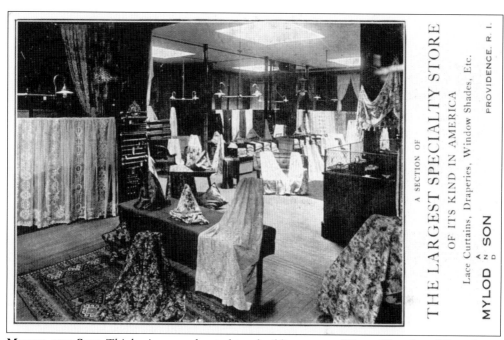

A SECTION OF THE LARGEST SPECIALTY STORE OF ITS KIND IN AMERICA

Lace Curtains, Draperies, Window Shades, Etc.

MYLOD AND SON PROVIDENCE, R. I.

Mylod and Son. This business was located two buildings west of Grace Church on Westminster Street in the downtown area. Advertised as "The Largest Specialty Store of Its Kind in America," they sold all kinds of window treatments, including shades, draperies, and lace curtains. They also sold sewing machines. The company is no longer operating.

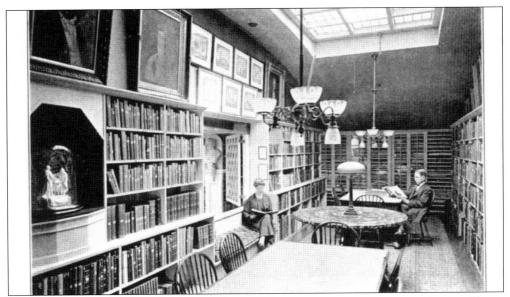

THE PROVIDENCE ATHENAEUM. Here is the interior of a reading room in the Providence Athenaeum on Benefit Street on the East Side. This granite, Greek-Revival structure, built between 1836 and 1838, houses the private library. The athenaeum was established in 1831 in rooms in the arcade on Westminster Street. The building was designed by William Strickland, a nationally prominent architect. Both Edgar Allen Poe and H. P. Lovecraft enjoyed spending time in this building.

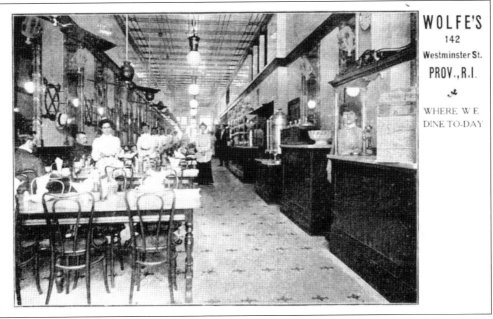

WOLFE'S, 142 WESTMINSTER STREET. Wolf's was an old-fashioned lunchroom. There are many period features in this scene, including hat racks at each table, the ornate cash register on the right, the large coffee urn, and the floor covering of small ceramic tiles. Note the row of neatly attired waitresses.

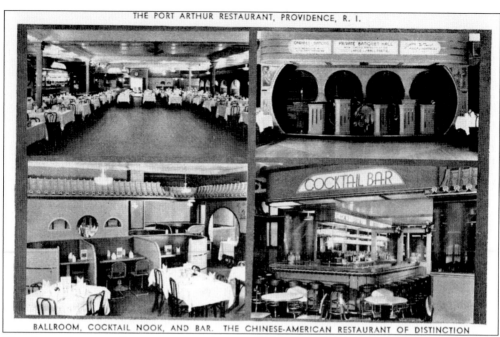

BALLROOM, COCKTAIL NOOK, AND BAR. THE CHINESE-AMERICAN RESTAURANT OF DISTINCTION

THE PORT ARTHUR RESTAURANT. The Tow family started this Chinese Restaurant, which was located on the second floor of 123 Westminster Street, and was known for its floorshows and its banquet hall. The restaurant closed its doors in 1965.

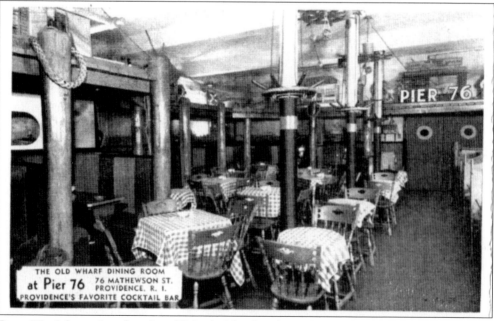

PIER 76. A long-time favorite of Rhode Islanders from the mid- to late 20th century, this downtown establishment was located first at 76 Mathewson Street, later on Fountain Street, and finally on Washington Street. It advertised having "An Old New England Seaport Atmosphere in the Heart of Downtown Providence." Leo Kiernan and Artie McKenzie ran the establishment at the time that this postcard was made.

Eight

BUSINESSES

FROM FLOWERS TO TIRES

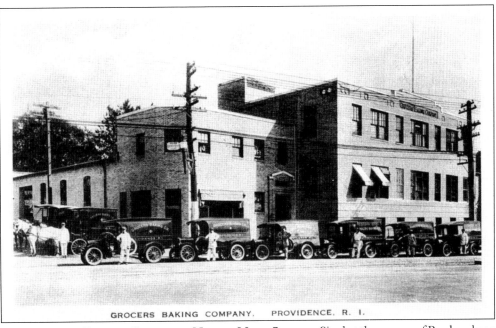

GROCERS BAKING COMPANY. PROVIDENCE, R. I.

THE GROCERS BAKING COMPANY, NORTH MAIN STREET. Sited at the corner of Rochambeau Avenue, six delivery vans and drivers pose for this picture in front of the building. There are also three horse-drawn wagons around the corner. On the back of the postcard is an advertisement for the McCormick Company, which designed bakery plants. In later years, the Hathaway Bread Company operated here. They sold Life Bread.

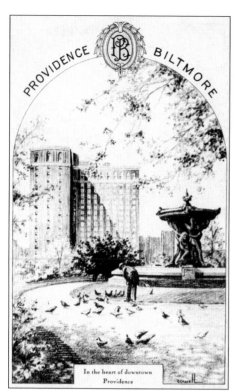

THE BILTMORE HOTEL, DORRANCE STREET. Completed in 1922 next to the city hall, the Biltmore has always been the jewel of Providence hotels. It was built by the Providence Chamber of Commerce, which saw the need for a major, model hotel in Providence and raised funds for its construction. The hotel is 19 stories high and has a beautiful view of Kennedy Plaza. In 1978 and 1979, the Biltmore was renovated, bringing it back to its original glory.

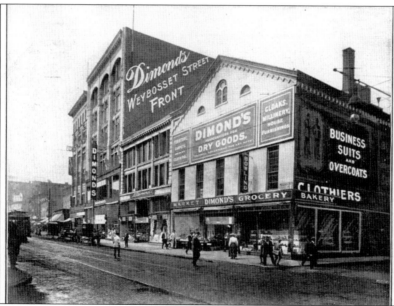

Dimond's
"Rhode Island's Fastest Growing Store."
Providence, R. I.

DIMOND'S STORE. Self-proclaimed as "Rhode Island's Fastest Growing Store," Dimond's occupied most of this block on Weybosset Street around 1910. They sold furniture, clothing for the family, household furnishings, and even had a bakery and grocery section. The building on the right is the 1849 Second Universalist Church, which was designed by Thomas Tefft. The Rhode Island Normal School (today Rhode Island College) was located here in 1852. The building still stands.

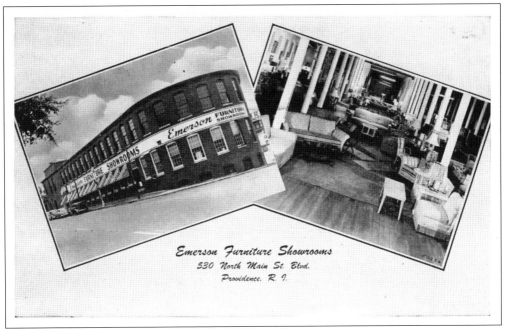

EMERSON FURNITURE SHOWROOMS, NORTH MAIN STREET. This 1951 advertising postcard shows the building across from University Heights. The building still stands, although Emerson is long gone. On the back of the card, the advertising tells us that the company sold Colonial, Moderne, or traditional furniture at low warehouse prices and for the customer, unlimited credit.

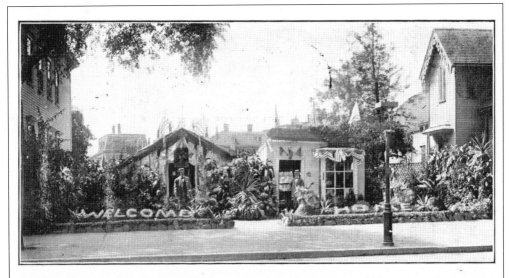

WILLIAM APPLETON, FLORIST. William Appleton's business was on Broadway, just out of the downtown area. His handwritten message on the back requests that customers come see his Easter display from April 12 to April 16, 1911.

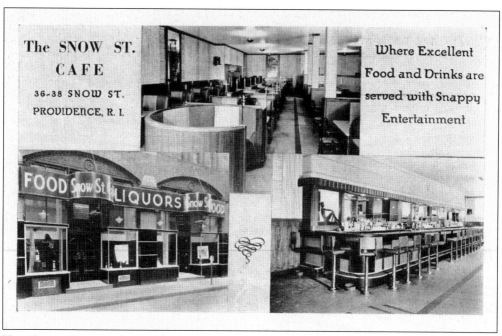

THE SNOW STREET CAFE. Showing its stylish art deco detailing on both its exterior and its interior, the café advertised on the back of the card with this message: "Smartest and Most Modern Cocktail Lounge in the State."

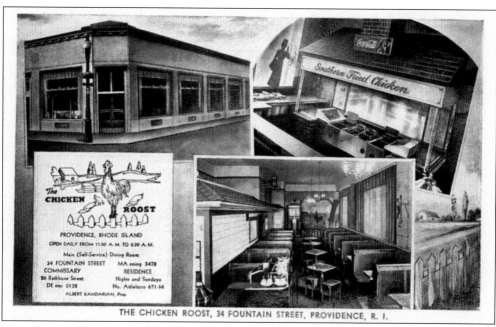

THE CHICKEN ROOST, 34 FOUNTAIN STREET, PROVIDENCE, R. I.

THE CHICKEN ROOST. For many years, the restaurant sold their fried chicken on Fountain Street in the downtown area. Author Louis McGowan can still picture the chickens hanging in the windows, waiting for hungry customers.

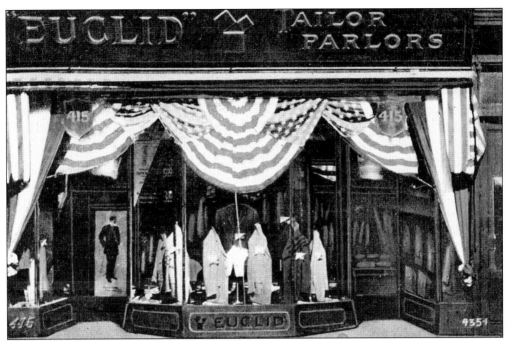

THE EUCLID TAILOR PARLORS. This *c.* 1910 postcard shows the storefront located at 415 Westminster Street in the downtown area. On the back is a printed message stating that Euclid had declared bankruptcy, and that the entire stock would be sold at one third the regular price. Note the nice old-fashioned sidewalk-level window displays.

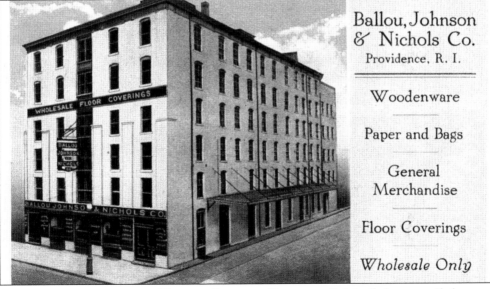

THE BALLOU, JOHNSON, AND NICHOLS COMPANY BUILDING. Originally known as Shakespeare Hall, the building was located on Dorrance Street in the downtown area. It was built as a three and a half-story, temple-front theater in 1838. After a fire in 1844, it was rebuilt and used as a warehouse by the A. and W. Sprague Manufacturing Company and later by the B. B. and R. Knight Company. After that, it was used as an office and a warehouse by the Ballou, Johnson and Nichols Company, hard foods wholesalers, from 1903 to 1977.

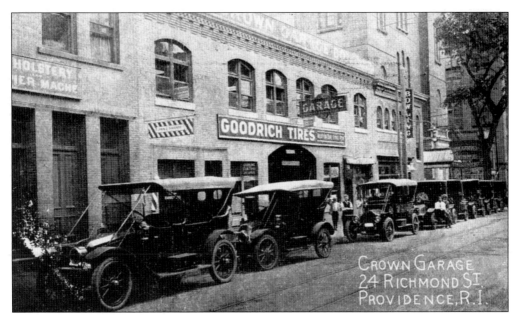

THE CROWN GARAGE ON RICHMOND STREET. The Crown Garage advertised that they used and sold Goodrich tires. The card was postmarked in 1914, so this wonderful line of automobiles dates from that period. The large brick building on the right housed Bullock's Temple of Amusement (later the Globe Theatre), which was probably an early movie house or one of the freak museums that were very popular at that time.

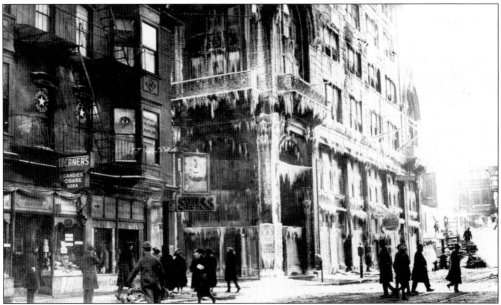

THE SHEPARD COMPANY. Occupying the large building on the right, Shepard's is seen after a fire on March 8, 1923. Founded in 1880, the business rapidly expanded to become the largest department store in New England. Shepard's occupied one city block from Westminster Street to Washington Street (which is seen in the foreground). Its reliable merchandise and its elegant building enabled the business to remain a favorite for shoppers until it went bankrupt in 1974. Today, the University of Rhode Island's Providence campus is located here.

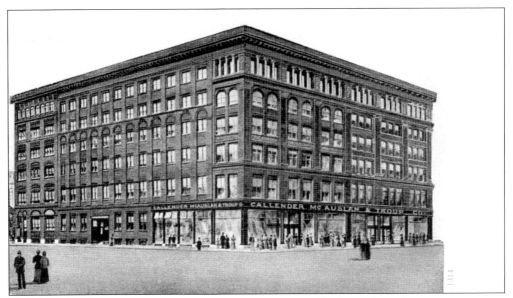

THE CALLENDAR, MCAUSLAN AND TROUP COMPANY. Established as a department store on Westminster Street in 1866, the company opened in a small building on the site. The business, which soon became known as the Boston Store, was immediately successful and began expansion in 1872. The building pictured here was completed the following year. The Peerless Company of Pawtucket bought the Boston Store in the 1950s and operated for many years as a clothing store in this building, which still stands.

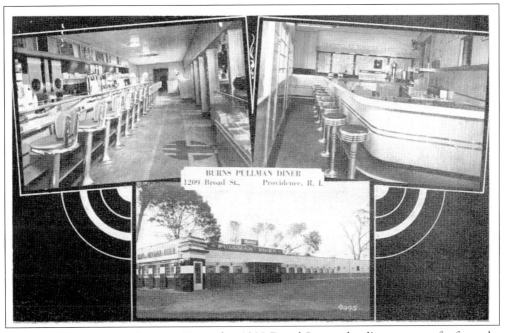

THE BURNS PULLMAN DINER. Situated at 1209 Broad Street, the diner was not far from the entrance to Roger Williams Park in Providence's south side. Harry E. Burns was the proprietor, and on the back of this postcard he bragged about his "Famous 'Burns' Toasted Frankfort." The diner is no longer here.

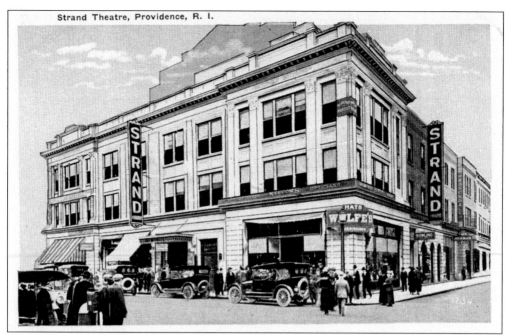

THE STRAND THEATRE. Built in 1916 on Washington Street, the theater was in continuous operation as a motion-picture house from 1916 until 1978. In recent years, it has been used as a concert hall. It was constructed with office space in the front part of the building. A 2005 proposal has been put forth to convert the theater space to condominiums.

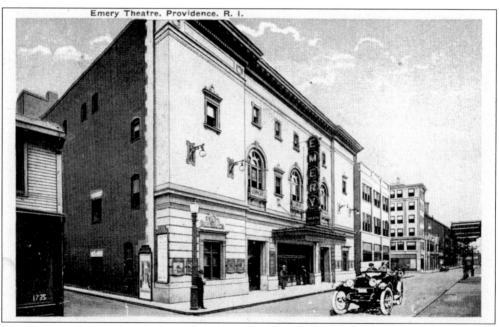

THE EMERY THEATRE. Later known as the Carlton, the theater opened in 1914 on Mathewson Street between Washington and Fountain Streets. It was a medium-sized theater with a lush interior, and in the early years, it featured both vaudeville and movies. In 1927, its name was changed to the Carlton. The building was demolished in 1954.

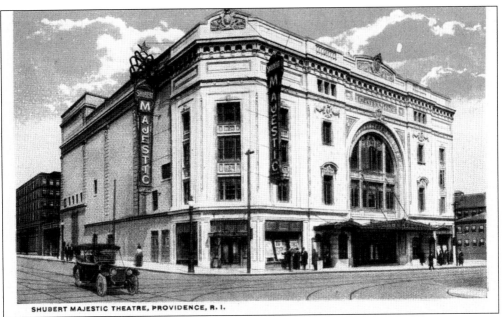

SHUBERT MAJESTIC THEATRE, PROVIDENCE, R. I.

THE MAJESTIC THEATRE. Now named the Lederer Theatre, the building was erected in 1917. Its ornate terra cotta facade, which faces Washington Street, is still intact. Built as Emery's Majestic Theatre, it was leased to the Shuberts from 1918 to 1923 and played major touring shows. After 1923, it showed movies until 1971, when the building became the home for Trinity Square Repertory Company. The elaborately detailed lower and upper lobbies have been restored, although the auditorium space has been gutted and rebuilt.

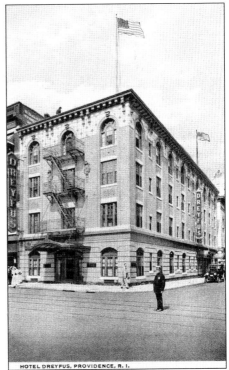

THE HOTEL DREYFUS. Built on Washington Street about 1890, the Dreyfus was a successful hotel with a popular café. Located in the heart of the downtown's bustling theater district, it was completely remodeled in 1917. It still looks much the same on the outside now and is occupied by Johnston and Wales University.

HOTEL DREYFUS, PROVIDENCE, R. I.

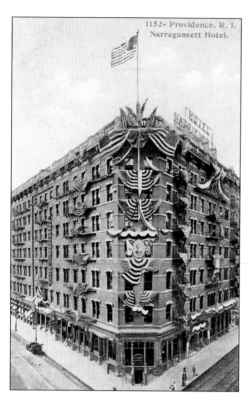

THE NARRAGANSETT HOTEL. Opened in 1878 at the southeast corner of Weybosset and Dorrance Streets, the Narragansett gave downtown Providence its first large and impressive hotel. Offering over 200 rooms and all the desired conveniences, it was indeed a first-class hotel. The Narragansett remained the prime hotel in the city well into the 20th century. It was demolished in 1960. Its parking garage, built in 1923 at 98 Dorrance Street, still stands.

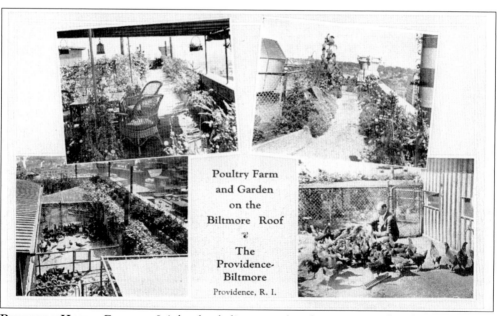

BILTMORE HOTEL GARDEN. It is hard to believe now, but there was a poultry farm and garden on the Biltmore Hotel roof. These endeavors from the 1920s served some of the hotel restaurant's needs. The hotel was long known as the Sheraton Biltmore. It is still operating as the Providence Biltmore Hotel.

THE CROWN HOTEL BUILDING. Located on Weybosset Street, the Crown Hotel building started life in 1894 as a clubhouse for the Providence Athletic Association, which went bankrupt not long after. The top two floors were added in 1901 for the new hotel. The Crown served as a hotel into the 1950s, by which time it had deteriorated greatly. It was bought and rehabilitated by Johnson and Wales University, but eventually it was torn down.

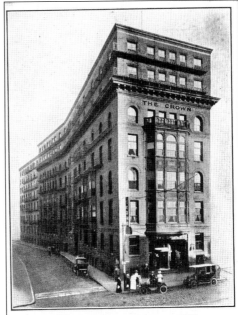

THE CROWN HOTEL

PROVIDENCE, R. I.

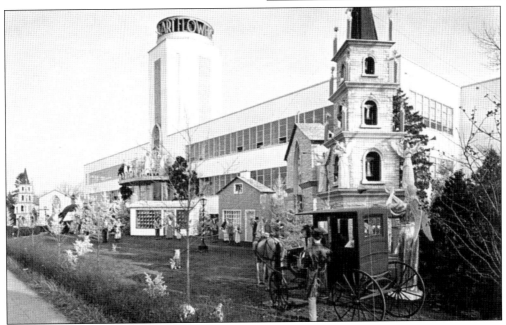

CALIFORNIA ARTIFICIAL FLOWER COMPANY (CALART). The business was founded in 1922 by Michael D'Agnillo, an Italian immigrant. He turned his hobby of making paper and cloth flowers into a livelihood. The flowers were first used by stores in window displays, but gradually the public accepted them for home use. The company expanded greatly in the 1930s and established sales offices across the country. To house this enterprise in 1939, Calart built, on Reservoir Avenue, the three-story brick structure shown here. The Christmas displays drew people from far and wide.

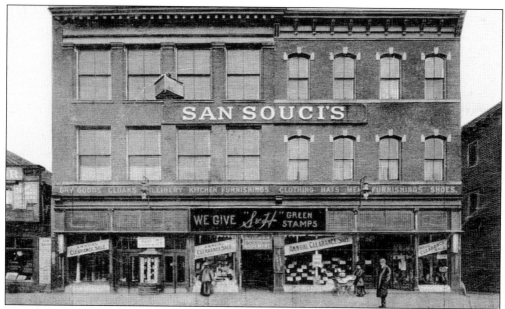

SAN SOUCI'S, OLNEYVILLE SQUARE. In 1900, Emery J. San Souci and his brother, Joseph O. San Souci, consolidated four smaller stores into the department store pictured here. By 1920, it was one of the largest in Providence, employing up to 125 clerks at a time. The patrons of the store were mostly mill workers from the neighborhood. Emery went on to serve as lieutenant governor of Rhode Island. The store operated into the 1950s. The building was torn down in recent years. As we can see from the postcard, they gave out S&H Green Stamps.

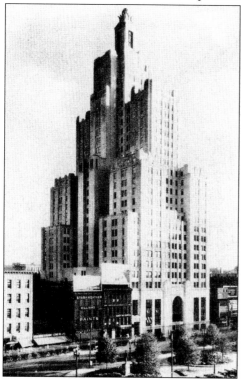

THE INDUSTRIAL NATIONAL BANK BUILDING. Built in 1928, this 26-story, art deco building is the city's best-known landmark, and its lights can be seen from miles away. The Industrial National Bank was the largest bank in the state. The building's architecture and art deco detailing relate it to notable New York skyscrapers of the time, namely the Chrysler Building and the Empire State Building. The building still serves as a banking institution, but the Industrial National name is long gone, having given way first to Fleet Bank and finally, to Bank of America.

THE UNION TRUST COMPANY BUILDING.
Located at the southeast corner of Dorrance and
Westminster Streets, the building dates to 1901,
although many additions and renovations were
made over the years. The Bank of America
was reorganized in 1894 as the Union Trust
Company. In 1900, the expanding company
started construction of this building. The
Industrial National Bank absorbed the Union
Trust in 1957. Industrial used the building until
1978, when the Greater Providence Trust took
over. Today the bottom floor is a restaurant.

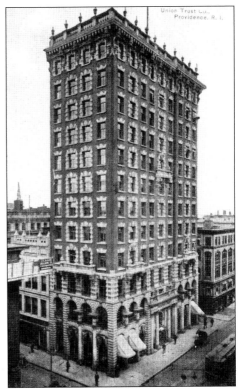

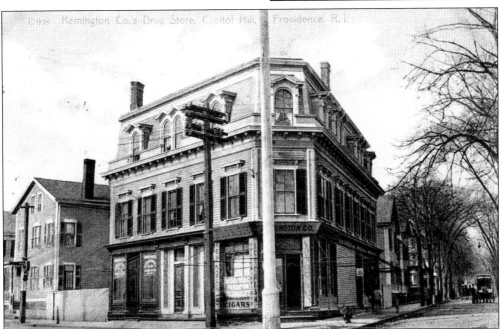

THE REMINGTON COMPANY DRUG STORE. Built as Goff's Grocery in 1873 on Smith Street,
diagonally across from the statehouse, Remington's was an example of the many small neighborhood
walk-in drugstores found throughout the city. This whole block was leveled to make way for
One Capitol Hill, a state office building.

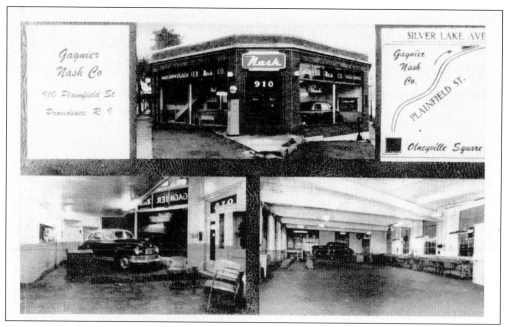

GAGNIER NASH, 910 PLAINFIELD STREET. For local people, Gagnier's in the Silver Lake neighborhood was the place to buy a new Nash in the 1940s and early 1950s. Nash cars were first built in 1917, and they were popular from the 1920s until their merger with Hudson in 1954 to form American Motors. The building is still there today, but the Nash is no longer here.

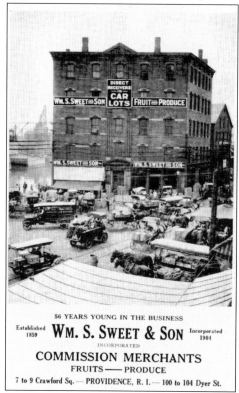

THE WILLIAM S. SWEET AND SON BUILDING. This *c.* 1915 advertising postcard shows the building on Crawford Square near the heart of the city's marketplace. Sweet's building was located along the waterfront and was near Market Square, where local farmers brought their goods to sell.

THE OUTLET SANTA CLAUS. The caption on the postcard, which dates from about 1907, says it all: "The Largest Santa Claus in the World – Forty Feet High." The Outlet Company always did it up big for Christmas. They had nice window displays and a big talking Christmas tree in 1980 during the last Christmas season that they were open.

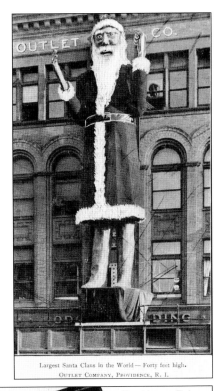

Largest Santa Claus in the World — Forty feet high.
OUTLET COMPANY, PROVIDENCE, R. I.

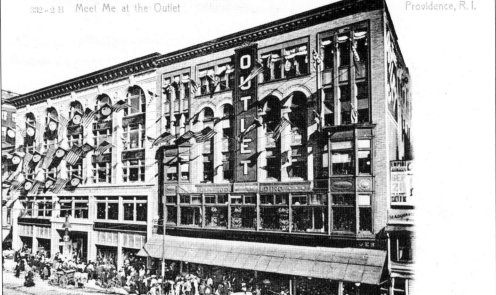

THE OUTLET COMPANY. "Meet me at the Outlet" was a familiar refrain heard throughout much of Rhode Island in earlier times. Located on Weybosset Street, the Outlet grew in stages and eventually became the largest department store in Rhode Island. It was established in 1891 by brothers Leon and Joseph Samuels. By the 1920s, the store occupied an entire block. The business closed in 1982, and the building burned to the ground in 1986. Today the site is occupied by Johnson and Wales University.

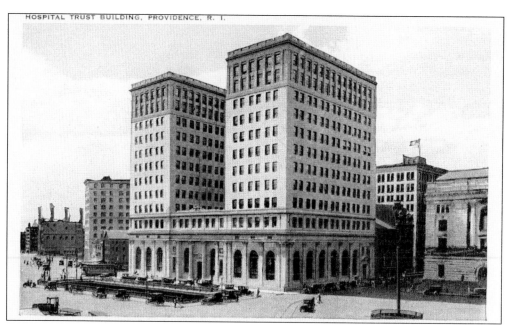

THE RHODE ISLAND HOSPITAL TRUST BUILDING, 1919. The company was the first trust company in Rhode Island. It was set up in 1867 to finance Rhode Hospital but soon went into commercial banking. This building was constructed in 1919 at 15 Westminster Street. In 1974, the bank constructed the 30-story tower behind this building. Today, the older building houses a dormitory for the Rhode Island School of Design, which also has plans to house its library here.

THE CITY HOTEL. The City Hotel was established in 1832 on Weybosset Street on the site of the Outlet Company. It was created by enlarging the Charles Dyer House (around 1820). Offering all the amenities of the big Boston inns, the City Hotel remained in business until 1903, when the building was demolished.

120

Nine

INDUSTRY

WHAT MADE PROVIDENCE GREAT

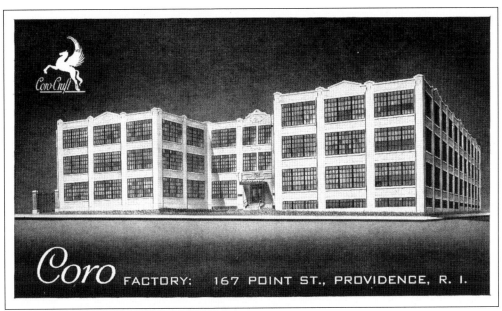

THE CORO COMPANY FACTORY, 167 POINT STREET. The business, started as the Cohn Rosenburger jewelry firm and located in New York City, opened a Providence branch in 1911. Coro commissioned Frank S. Perry to design a new building (shown here), which was completed in 1929 with a reinforced concrete frame. They were said to be the largest maker of costume jewelry in the world at one point. Coro closed this plant in 1979. Today, the building is occupied by Lifespan, a health care company.

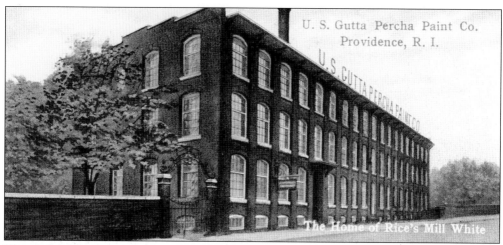

THE UNITED STATES GUTTA PERCHA PAINT COMPANY. Pictured here on Dudley Street, its second location in Providence, the company was founded by William Rice in 1886. Rice had invented an early latex paint that used Malayan gum-tree resins known as "gutta percha." His company also made oil-based paints and enamels and distributed their paint throughout the United States and overseas. The building shown here was built around 1906. By 1962, they had vacated this plant.

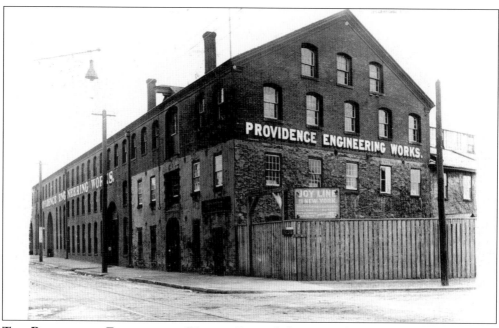

THE PROVIDENCE ENGINEERING WORKS. Formerly known as the Providence Steam Engine Company, Providence Engineering Works, located on South Main Street, started out building steam engines in 1821 and did so throughout the 19th century. In the 20th century, they built tractors for Maxwell Motor Cars. The company liquidated in 1955 because of decreased demand for steam engines. The building has been converted to mixed use, including housing, stores, and office space.

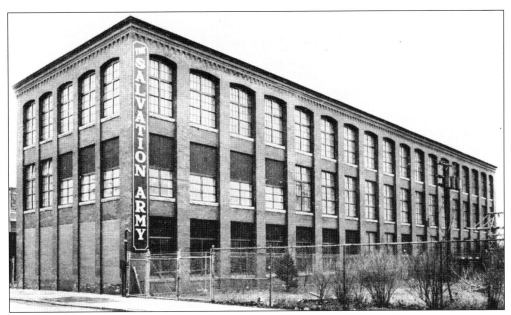

THE COLORED WORSTED MILLS. This late 19th-century textile mill building is located on Pitman Street on the East Side. The Salvation Army has occupied the building for many years.

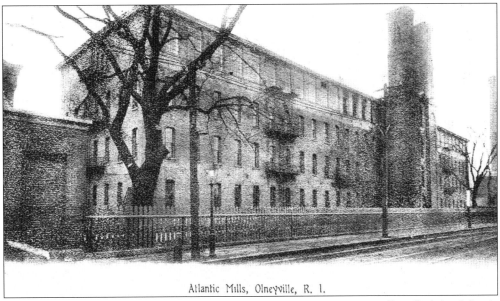

Atlantic Mills, Olneyville, R. I.

THE ATLANTIC MILLS, MANTON AVENUE. The first building, originally called the Atlantic Delaine Company, was built near Olneyville Square in 1851. A number of buildings were added later, one of which is pictured here. The mills were known for their fine alpaca cloth, but the firm went bankrupt in 1873. In 1879, the Atlantic Mills started. Their 2,100 workers produced worsted and cotton warp fabrics. The A. D. Juilliard Company bought the mills in 1904 and ran the mills for nearly 50 years. Various other businesses have occupied the main buildings since.

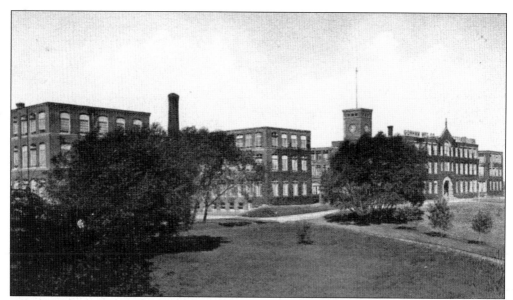

THE GORHAM MANUFACTURING COMPANY. Starting with a jeweler's shop in 1818, Jabez Gorham started making silver spoons in 1831, which were soon followed by other silver items for the home. His son John Gorham greatly expanded the business. From the 1880s on, the company handled large orders for bronze statues and memorials. Having outgrown their North Main Street plant, the complex pictured here was built starting between 1888 and 1890. In 1967, Gorham became a division of Textron.

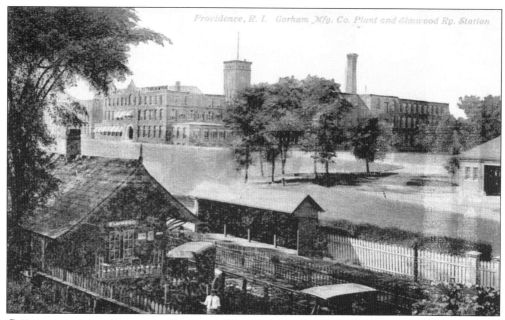

GORHAM AND THE ELMWOOD STATION. The whole Gorham complex was recently demolished. People just do not use silver around the home the way they used to. In the foreground can be seen the Elmwood Station on the main line of the New York, New Haven and Hartford Railroad. Being close to the train line was essential in the old days for a business such as Gorham.

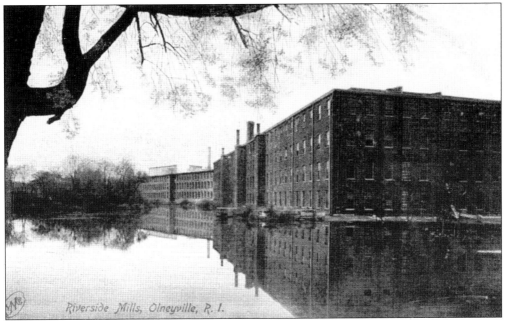

THE RIVERSIDE MILLS, ALEPPO STREET. The business started in 1863 as a woolen mill built by George C. Chapin and Lewis Downes. They originally made woolen and cassimere products, but they soon changed to cloth for ladies' cloakings and to worsted cloth for men's wear. Around 1890, the mills employed 2,700 workers. In 1899, the firm was bought by the American Woolen Company, a huge textile conglomerate. It operated the mills until 1937. In 1989, a fire destroyed most of the complex.

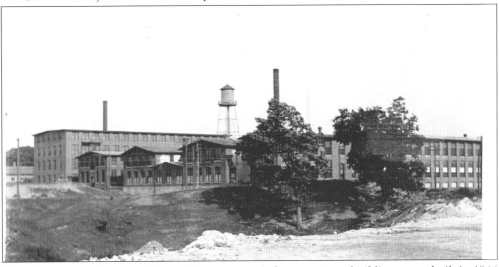

THE ELMWOOD COTTON MILLS. The company's first two stone buildings were built in 1866 by the James Y. Smith Manufacturing Company. They made cotton cloths, prints, sheetings, and fancy goods. In 1891, the business, then run by F. H. Potter, produced 450,000 yards of cotton goods a year. The William E. Joslin Company, makers of shoelace and braid, bought the company in 1895. In just a few years, they sold out to the Elmwood Mills, who made the same products. They erected the early 20th-century buildings on the site. Cable Electric Products bought the mills in 1948.

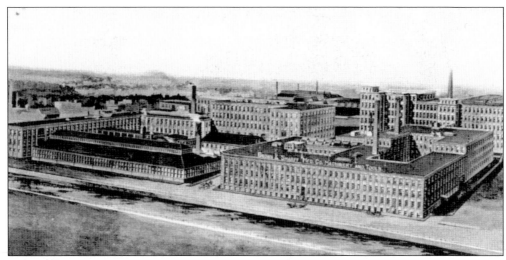

BROWN AND SHARPE MANUFACTURING COMPANY. The firm began as a small watch and clock making company founded by David Brown and his son Joseph in 1833. In 1841, Joseph Brown took over the business and began making small tools and lathes on South Main Street. His first important invention made possible the production in 1851 of the vernier caliper, an important tool for machinists. In 1853, Lucian Sharpe joined the company.

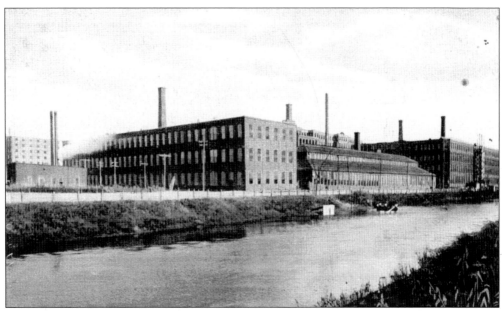

BROWN AND SHARPE, FROM ANOTHER ANGLE. The firm made important advances in precision measuring and machine tools throughout the 19th century. In the 1860s, they also designed the turret lathe, the Universal Milling Machine, and the Universal Grinding Machine. In 1872, they moved to the Promenade Street location and became the largest producer of machine tools in the nation. The firm continued to grow and prosper until 1964 when they moved to North Kingstown, Rhode Island.

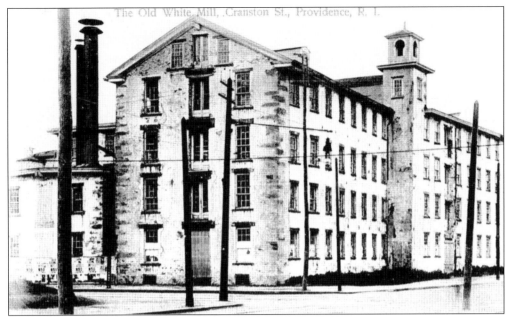

THE OLD WHITE MILL, CRANSTON STREET. At various times it has functioned as a gristmill, a woolen mill, a cotton mill, and a state arsenal. Troops were stationed here in 1842, and the building was unsuccessfully attacked by Thomas W. Dorr's forces during the Dorr Rebellion. Dorr was looking to have a state constitution put into place, something that Rhode Island did not have at the time. In 1875, it was occupied by the Groton Manufacturing Company. The Cranston Street Armory now occupies the site of the Old White Mill.

THE MANTON MILLS. Sited just off Manton Avenue along the Woonasquatucket River in the Manton section of Providence, the firm traced its roots back to the 1820s. It was owned by a number of companies in the 19th century, including the Lonsdale Company. The American Worsted Company bought the mills in 1899 and operated here in the 20th century. Today, the buildings have all been destroyed.

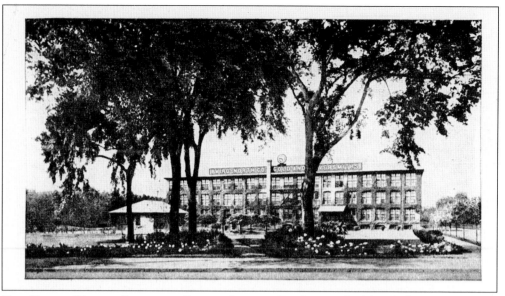

THE BAIRD-NORTH COMPANY, BROAD STREET. Producers of gold and silver items for the home and for jewelry, the company was founded by William Gilmore Hussey of Augusta, Maine. In 1907, Hussey moved the business to a new brick building in Providence, pictured here. Baird-North's business was mainly mail order. George, one of William's two sons, ran the business from 1908 to 1918.

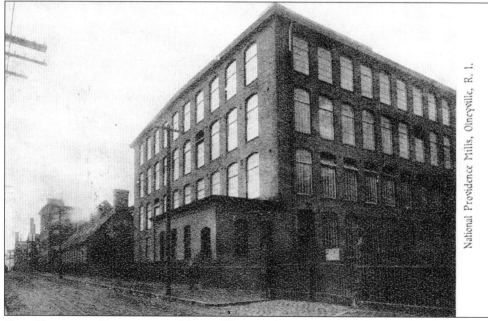

THE NATIONAL PROVIDENCE MILLS, VALLEY STREET. Located on Valley Street in the Olneyville section, the company began in 1867 when Charles Fletcher started the Providence Worsted Mill. He added the National Worsted Mill in the 1880s and combined the two in 1893. The American Woolen Company bought the 10-acre complex in 1899 and ran it until the 1950s. Other non-textile businesses now occupy the buildings.